WILD WITH CHILD

OUTLAW MOTHERS AND FEMINIST REPRESENTATIONS OF MATERNAL POWER

Edited by Rebecca Jaremko Bromwich
and Elana Finestone

DEMETER

Wild With Child
Outlaw Mothers and Feminist Representations of Maternal Power
Edited by Rebecca Jaremko Bromwich and Elana Finestone

Demeter Press
PO Box 197
Coe Hill, Ontario
Canada
K0L 1P0
Tel: 289-383-0134
Email: info@demeterpress.org
Website: www.demeterpress.org

Demeter Press logo based on the sculpture "Demeter" by Maria-Luise Bodirsky www.keramik-atelier.bodirsky.de

Printed and Bound in Canada

Cover and section image: Clara Kundin photographed by Sheri Furneaux
Cover design and typesetting: Michelle Pirovich
Proof reading: Jena Woodhouse

Library and Archives Canada Cataloguing in Publication
Title: Wild with child: outlaw mothers and feminist representations of maternal power / edited by Rebecca Jaremko Bromwich and Elana Finestone.
Other titles: Wild with child (2024)
Names: Bromwich, Rebecca, editor. | Finestone, Elana, editor.
Description: Includes bibliographical references.
Identifiers: Canadiana 20240328167 | ISBN 9781772584929 (softcover)
Subjects: LCSH: Motherhood. | LCSH: Mothers.
Classification: LCC HQ759.W55 2024 | DDC 306.874/3—dc23

 The publisher gratefully acknowledges the support of the Government of Canada

This is dedicated to all those still busy being born,
all of the beginners; to the new mothers, pregnant people,
people new to maternal feminist thought, our younger selves,
our children, and our future

We would like to thank everyone who helped birth this book.
Thank you Andrea O'Reilly who graciously found a home for
the book at Demeter Press. Thank you Michelle Pirovich,
our type-setter, and Jesse O'Reilly-Conlin, our copy-editor,
for being magicians at the final hour of publication.
We are indebted to you for the time and effort you have
put into this book.

This publication would not be possible without the creative
work of our contributors. Thanks for helping us continue
to reimagine what motherhood can look like if we create
space for the rich diversity of experiences and voices.

Last but not least, we would like to thank our mothers
and our children. Without you, we would not have had the
opportunity to be mothers.

Table of Contents

Wild With Child: Outlaw Mothers and Feminist Representations of Maternal Power

Rebecca Jaremko Bromwich and Elana Finestone

> If you don't like something, change it.
> If you can't change it, change your attitude.
>
> —Maya Angelou

We were having trouble finding a book that would make sense as a feminist gift for pregnant people and mothers. So, we thought we would make one. Dear reader, we imagined you as a pregnant woman, a new mother, or a mother new to maternal feminist scholarship, and we wanted to invite you into a lively conversation already taking place. In conceptualizing this book, we were not just aware but actually in awe of the depth of feminist maternal scholarship available —much of it published through the relentless and prolific work of Demeter Press—to create a space for academic and theoretical and facilitate creative, critical conversations about motherhood and motherwork.

We are writing at a time when theatres are overflowing with moviegoers lining up to see the unprecedented blockbuster box office success of Greta Gerwig's genre-transcending, corporate-funded, yet subversive *Barbie* movie. It seems, in 2023, that the cultural moment in mainstream

Western societies is ripe for moving what have largely been conversations among academics into the popular mainstream and injecting them into joyful moments of comedy and art. There seems to be an openness on the part of women who do not necessarily identify as feminists to consider new ideas in solidarity with other women.

What we hope to accomplish with this book is to provide an enjoyable, emotionally resonant, and accessible entry point into feminist maternal scholarship and into honest and authentic conversations about the experiences felt in being a mother for people who are not otherwise likely to go looking for the body of scholarship that currently exists.

So, what we have curated here is a hybrid text that both draws from and is located on foundations of feminist maternal theory but is deliberately presented and written in an accessible format and style. It bears many similarities in theme and conceptualization to Michelann Parr and BettyAnn Martin's Demeter Press anthology *Mothering Outside the Lines: Tales of Boundary Busting Mamas* (2023), as that book also explores the boundaries of maternal practice and representation. Shared by this book with that anthology is a hopeful stance: We can not just critique oppressive contexts; we must also transgress them and enjoy doing so.

Motherhood is culturally constructed in Western societies as related or equivalent to domesticity. The dominant narrative is that motherhood is "settling down", and is thus a conclusion to one's wild autonomy. There is a powerful patriarchal cultural expectation that motherhood will turn a woman into someone either idealized or lacking. This idealization of mothers as "settled" needs to be understood within the context of a white supremacist, patriarchal, capitalist worldview. In the dominant western cultural narrative, motherhood is a happy ending. In this understanding of motherhood, an ideal mother is white, and submissive, and hardworking, and bourgeois. She has surrendered her autonomy, she has ended her adventures. But this construction is at odds with so many experiences we have. Our lived understanding of pregnancy and parenthood is that these things are encounters with the untamed in ourselves and others, not the end to our adventures but part of them.

What if carrying a pregnancy—or not—and giving birth are not domestic tasks but some of the wildest things we do? Andrea O'Reilly talks about "outlaw motherhood" as mothering in wildness, recognizing the profound and uncivilized connections being a mother involves, the strong love of one's children or one's partner. What if motherhood has

been domesticated with such rigorous discursive effort precisely because it is such a wild space—a place of muddy, messy interconnectedness that is very hard for the political philosophy of liberalism and the laws of capitalist liberal democracies or any society—to control? The private sphere, to which women are so often relegated, is also a space where there is access to power. Maybe, just maybe, the strong prohibitions and valorizations around motherhood have their roots in fear.

We wanted to put together an anthology encouraging mothers and pregnant people to step into their strength and bravery to accept and affirm their experiences. Like Cheryl Strayed knew when she undertook the hike she narrated in her memoir *Wild* (2012), we know that our imaginations can be limited and can be expanded by the stories we tell ourselves; fear is often born of stories we tell ourselves, and so are many other emotions and experiences. What if pregnant people and mothers told themselves stories about being brave, bold, good enough, and wild?

Thus was born *Wild with Child*. Our intention in putting together this anthology is to curate an inspirational collection of feminist representations of maternal power. As coeditors, we conceived of this project as a means to build accessible, empowering, and celebratory visual texts and written counternarratives about how we imagine those who are pregnant and mothers. Our intention in producing this work is to bring into being an accessible cultural artifact that mindfully and intentionally intervenes in and counters the multiplicity of problematic images, tropes, stereotypes, and imaginings that are pervasive in Western cultures and influence, affect, and shape maternal experiences and women's relationships to our bodies and lives, as well as to our children.

For decades, feminist academic researchers, such as O'Reilly, have questioned the limiting representations of pregnant women, mothers, and motherhood as either good or bad (Hager et al.; Douglas and Michaels), idealized or blamed (Ladd-Taylor), or icons or monsters (Thurer). We wanted to build on those critiques to construct new discourses, narratives, and imaginings that creatively challenge stifling and oppressive representations. While there is a growing body of maternal feminist literature that provides feminist critiques, and while O'Reilly's vision of "mother outlaws"—mothers who exist in a space of meeting their needs and those of their children, of collaborating, of radically accepting life as it is lived, and of understanding maternal ambivalence alongside maternal love—is compelling indeed, there remains a dearth

of accessible presentations of mothers as powerful figures that are inclusive and feminist. We, therefore, put out a call for submissions that build on this academic work in a format that is accessible to the public and, in particular, people with lived experience of pregnancy and motherhood. We are seeking not just to inspire feminist mothers but also to intervene and interrupt dominant constructions of motherhood and pregnancy that are prevalent in mainstream Western societies.

The vision for this book arose from our experiences during COVID-19 at two moments at different places on the timelines of motherhood. In particular, this book was inspired by one coeditor's disappointment in the available maternity photoshoot options capturing demure and stoic pregnant heterosexual women. When this book was first conceptualized, Elana was pregnant with her first child and Rebecca was a newly solo parent to four teenagers who were grounded by the COVID-19 lockdowns with her. In a world less physically constrained by COVID, Elana is the mother to a toddler and one of Rebecca's teenagers has already flown the nest into their grown-up adventures.

Both of us are feminists, and we are both familiar with feminist maternal critiques.

Other contributors to maternal feminist theory and feminism (e.g., Rich, Ruddick, and Griffin) have helped us understand social constructions of motherhood and pregnancy as mandatory, as circumscribed in patriarchy. There is a burgeoning literature about what is wrong, what is problematic, what needs to be troubled in the current cultural constructions of femininity, the gender binary, maternity, motherhood, what is unfair about unpaid labour burdens and the consignment of women into the private sphere, the desexualization of the maternal, the subordination of women, the feminization of poverty, maternal poverty, the massively disproportionate burden of the pandemic lockdowns on mothers, the false and misleading dichotomies of the "mommy wars," the racial and white supremacist constructions of the "good" and "bad" mother, the emerging discussions of reproductive justice, the intersection of colonialism with the cultural genocide against Indigenous peoples in Canada. We have read about these things, talked about these things, and contributed to the literature on these things. We are grateful for thinking, writing, and talking with feminists for many years about these things.

Yet we came up short when faced with the question of where to look

for good ideas, for inspiration—not shallow, positive, "good vibes" for "self-care" but for thoughtful, careful suggestions and inspiration about what it might look like to get this right. How might mothers be portrayed differently? How can we step into our power? What book might we give someone, perhaps a friend, one of Rebecca and Elana's daughters a day in the future, as a baby shower gift? We wanted to curate a book that we could imagine handing someone and and saying here—I entrust you with this treasure, a treasure that speaks to the wonderous, wild adventure you are on.

There is a place for critique. We want to read more of it. We must understand mothers as flawed and powerful (Walker). It is important to tell our truths. Amid deep and thoughtful feminist conversations, we wanted also to empower.

This collection's chapters, from a wide range of fields, help us curate an accessible and inclusive space to reimagine how those with pregnant bodies and mothers from diverse backgrounds can relate to their new bodies, lives, and circumstances while navigating their social worlds. This is an anthology of creative texts, which captures the fun and freshness of dismantling heteronormative, classist, ableist, and racist tropes. These tropes tend to be at the forefront of mothers' and pregnant people's lives—which are not only oppressive but also boring. We sought images, writing, and other creative works that we can bring together into a lively book that will bring readers across disciplines inspirations, new ideas, new perspectives, and joy.

For this collection, we are grateful to be able to present submissions from scholars, activists, artists, and people with lived experience of pregnancy, motherhood, and/or mothering across a wide variety of disciples. In this anthology, you will find creative works, art pieces, photographs, and alternative modes of presentation that represent, or consider representations of, mothering, motherhood, and the pregnant body, as powerful.

Along with the wide range of written work, we are pleased to present images that communicate about the wild-with-child experience in a completely different way.

There are of course limitations to this collection. It is a snapshot in time in terms of our thinking. We sought to curate contributions from a diverse range of contributors concerning race, Indigeneity, and queer life experiences. We acknowledge there is a Western-centric bias in

much writing about mothers and, as white, middle-class women, we worked hard to address but struggled to fully account for the biases and blindspots resulting from that positionality in society. We hope that this book will lead to burgeoning conversations among many people and that it will inspire further work. We also hope it may lead those who read into curiosity about, and engagement with, more in-depth maternal feminist scholarship, specifically the collected works published by Demeter Press, which are quite wonderful and should be read by more people both outside and inside of academia.

The book is organized into three parts: Pregnancy, Birth, and Motherhood.

The Chapters

We are excited and honoured to present a summary of the contributions to this book. The following is a discussion of the contributions in this volume concerning how they connect to these themes.

Pregnancy

Linda Greene-Finestone explores the story of Lilith in her piece, "From Rejection to Redemption," a tale that offers a reconsideration of the wildness inherent in motherhood and the feminine.

Micha Colombo's poem "queen" shows, in a very unusual style, how pregnant women are viewed and the comraderies that develop between all women who are mothers, whether they are older or younger. In her poem, the woman feels she is unfurling, like a flower—an interesting image of a developing pregnancy—and how that feeling overcomes "lethargy, nerves, gripes, and restless energy."

Elana Finestone creates space for a new style of maternity photos where women can be both vulnerable and powerful. Elana helps us imagine what it could look like for pregnant people to bring their whole self to a maternity photo-shoot. Beyond joy and well wishes for her future child, Elana brings other facets of herself to the forefront—a lawyer, a person who uses anti-depressants and yoga to manage her mental health, a future mom who yearns to share her love of literature with her future child and a feminist who strives for an equal parenting relationship with her partner.

In "A Tough Pill to Swallow," Sarah Sahagian explores challenges related to mental health treatment in the context of pregnancy and birth, looking critically at how mental health issues faced by mothers are stigmatized. Sahagian writes that she had a tough pill to swallow and it wasn't medication. It affected her much more than any pill might, or might not. Sahagian relates how one encounter with a pharmacist left her with a better understanding of what she needed—and didn't need. Going through some classic, and newer, feminist writing, Sahagian shows how women know how to care for themselves, even when others try to steer us in a different direction.

In "Maternity Photography: Beyond the Gender Binary," Clara Kundin explores the experience of maternity photography, using her unique perspective of having worked as a portrait model during her pregnancy. She participated in dozens of maternity photo shoots, primarily with male photographers. While each photographer claimed to want to capture a sense of maternal power, the pressure to look elegant and somehow still sexy in each photo made her instead feel disempowered and misrepresented in her maternity experience, particularly as someone who (while pregnant by choice) did not enjoy the experience of pregnancy. It was only by working with trans, nonbinary photographer Sheri Furneaux that Kundin could create a maternity image that captured her true sense of pregnancy, something beautiful and grotesque.

Birth

Andrea DeKeseredy shares stories from four Canadian women who were pregnant during COVID-19. Little attention has been given to the experiences of pregnant women as Canada continues to recover from the pandemic. In "We're Badass Moms: A Narrative Inquiry into Women's Experiences of Pregnancy and Delivery during the COVID-19 Pandemic," she writes, "Through ever-changing hospital policies, socialization restrictions, closure of childcare facilities, and the increased risk from the virus, pregnant women's lives were affected in irreversible ways. While the unexpected challenges of the pandemic were daunting, navigating them allowed women to recognize new-found strength and maternal power."

Wendy McGrath uses a few lines in "words about birth" that also say so much. This is from her first poetry collection, *common place ecstasies*.

The image she evokes could be from a pregnant woman's ultrasound to her meeting her child for the first time. It is up to the reader as meaning is in the eye of the beholder.

Lauren McLaughlin's art presents an infrequently portrayed image that remains essentially taboo; her neon light piece "The Creation of the World" depicts the moment of birth.

Motherhood

In "Mothering against the Grain: Preserving the Self by Losing it and Finding the Self by Preserving It," May Isaac explores the idea of preserving the Self by losing it and then flips this to tease out the notion of finding the Self by preserving it. For many women, the search for Self is expressed as a mother quest or finding her Self through recuperating her maternal heritage and a reconciliation of her childhood. In the second section, by going against the grain of her mothering practices, May lays bare the process by which, lately, she has tried to preserve her Self by finding it.

Now a solo mom to teens, in "Still Wild," Rebecca Jaremko Bromwich relates her experience of mothering in a variety of social contexts, from parenting toddlers and preschoolers as a middle-class married woman to parenting teens solo in a shared custody situation.

In "Journeys into Liberation: Rewriting the Maternal "I/My" in Poetry on Domestic Abuse," Guinevere Clark fuses creative and theoretical understandings around experiences within maternal domestic abuse. Using a curated sample of poems from her PhD collection, *The Egg in the Triangle*, she analyzes a maternal journey into liberation from domestic abuse and discusses abuse as a state of potential transition and transformation. She proposes that experimental poetry on domestic abuse, especially in supportive environments, can help break taboos, simplify complexities, and improve general societal awareness. Clark also aims to inspire mothers to write from their own experiences of abusive situations.

In "Writing the Breast: The Hyphenated Sign," Claudia Zucca examines several different forms of literary work that "write the body," including her poetry, which tells her story of being unable to breastfeed her child. She examines the societal guilt and shame relating to whether a woman breastfeeds or not. She writes, "The breast is part of a complex

whole. To write the breast is to write the body. To write the body is to write the personal and to make it public."

In "Bloody to the Elbows," Jennifer Cox presents five poems on mothering through birth trauma that take the reader through the difficulties of being in an intensive care unit (ICU), sharing or not sharing the birth experience, finding a way to best deal with a newborn, and, finally, the joy of motherhood. Although each poem is short, there is so much that can be read into them.

As a survivor of sexual abuse, Hazel Katherine Larkin discusses the changing relationship she's had with her breasts since becoming a mother.

In "Untitled," Laura Simon deals artistically mainly with the theme of regretting motherhood and the role models of women in our contemporary Western society. In her work, she tries to express the hidden feelings of women, especially of mothers, such as regret, fear, overload, and longing. She wishes to encourage women to free themselves from the preconceived expectations that society and family consciously or unconsciously place on them.

In "'There Must Be Something Good About Me': Dystopian Satire, Maternal Resistance, and the Undoing of Normative Motherhood in Jessamine Chan's *The School for Good Mothers*," Andrea O'Reilly looks at the potential of dystopian satire in novel form to be a venue for maternal empowerment and maternal feminist thought. In discussing a novel recounting the harrowing and unscrupulous surveillance of mothers who are doomed to failure certainly, O'Reilly examines a text that seeks to, as does this anthology, dismantle heteronormative, classist, ableist, and racist tropes of mothers and mothering and in so doing delivers a formidable critique of the institutions of normative and intensive mothering.

Zoe Zeng's cartoon "Mama" comically explores maternal ambivalence and the disproportionate emotional burden too often carried by mothers in heterosexual couples in parenting.

We hope, dear reader, that in looking through this anthology, you can enjoy and emotionally engage with visions of pregnancy and motherhood that run counter to broadly accepted cultural narratives and tropes, seeing pregnancy and motherhood as potential journeys of empowerment. We are hoping that if you are embarking on your journey as a mother, you feel seen and safe to acknowledge the complexities and

nuances of motherhood in all its forms. You are not alone in experiencing motherhood as beautiful, difficult, and complex.

We have striven to embrace the diverse experiences of mothers from various walks of life, recognizing that the intersectionality of their identities enriches our understanding of the profound role they play in our world. There will always be limitations to these efforts, and our anthology is no exception to that. We are both white women who live in Canada, and we are both comfortably middle-class professionals. We actively sought contributions from those socially positioned in different racial, geographical, or socioeconomic situations and also sought to include contributions affirming the experiences of LGBTQ+ mothers, young mothers, and mothers who face financial challenges or have working-class roots. This was not easy. In part, this is due to the limitations of our professional and academic networks. In part, also, it is because, as Virginia Woolf famously wrote, to produce art or write fiction, a woman must have a room of her own, and there remain far too many pregnant women and mothers who do not have the leisure or comfort to be able to readily contribute to an anthology such as this. We encourage readers to look through the other offerings by Demeter Press to explore the diverse array of writings and creative works about motherhood it offers.

More generally, we encourage our readers to delve deeper into maternal feminist scholarship. The stories and essays within these pages are an entry point into a lively broader conversation about motherhood, and we are inviting you to participate in it. By engaging with maternal feminist scholarship, we can expand our awareness, challenge stereotypes, and work towards a more inclusive and equitable world for all mothers.

Works Cited

Angelou, Maya. *I Know Why the Caged Bird Sings.* Random House, 1969.

Douglas, Susan J., and Meredith W. Michaels. *The Mommy Myth: The Idealization of Motherhood and How It Has Undermined All Women.* The Free Press, 2004.

Griffin, S. "Feminism and Motherhood." *Mother Reader: Essential Writings on Motherhood,* edited by M. Davey, Seven Stories Press, 2001, pp. 33-46.

Hager, Tamar, et al,. eds. *Bad Mothers: Representations, Regulation, and Resistance.* Demeter Press, 2017.

Ladd-Taylor, Molly. "Mother-Worship/Mother-Blame: Politics and Welfare in an Uncertain Age." *Maternal Theory: Essential Readings,* edited by Andrea O'Reilly, Demeter Press, 2007. pp. 660-67.

O'Reilly, Andrea, editor. *Maternal Theory: Essential Readings.* Demeter Press, 2007.

Parr, Michelann, and BettyAnn Martin, editors. *Mothering Outside the Lines: Tales of Boundary Busting Mamas.* Demeter Press, 2023.

Rich, Adrienne. *Of Woman Born: Motherhood as Experience and Institution.* Norton, 1976.

Ruddick, Sara. *Maternal Thinking: Toward a Politics of Peace.* Beacon Press, 1989.

Strayed, Cheryl, *Wild: From Lost to Found on the Pacific Crest Trail.* Knopf, 2012.

Thurer, Shari L. *The Myths of Motherhood: How Culture Reinvents the Good Mother.* Houghton Mifflin Co, 1994.

Walker, Alice. *Possessing the Secret of Joy.* Harcourt Brace Jovanovich, 1992.

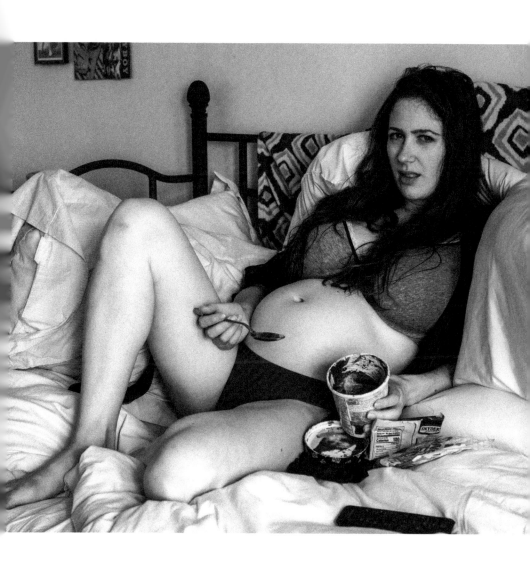

PART I.

PREGNANCY

1.

Lilith: From Rejection to Redemption

Linda Greene-Finestone

Who is this woman named Lilith? Lilith has been variously described as a symbol of equality, a demonic figure, a night monster, and a figure of strength and independence. The creation of Eve from Adam's rib is a familiar story (Genesis 2:22). Here, Eve is created after Adam. But the lesser-known Lilith has been described as Adam's first wife who was created in God's image: "And God created humankind in his own image, in the image of God He created them; male and female he created them" (Genesis 1:27). Here, Lilith and Adam are created at the same time.

The *Alphabet of Ben Sira*, a Jewish text written in the Middle Ages, describes her story. Lilith would not be subservient to Adam and fled the Garden of Eden ("Gan Eden" in Hebrew). God sent three angels to drive her back, but she refused. The angels told Lilith that they would kill one hundred of her children each day for being disobedient. In retaliation, she threatened evil on infants, which could be countered by wearing protective amulets bearing the names of the angels. In her struggle with Adam, Lilith chose independence and was punished and replaced by Eve. Though near, the promise of motherhood of multitudes was thwarted. Instead, a forbidding narrative portrayed Lilith as a demoness, a night monster, and a seductress. In art and writings throughout history, Lilith has been depicted in many forms—with a serpent, as a half-woman and half-snake, and as a woman with beautiful, flowing hair. Was her story to be an example of retribution for those who challenged authority?

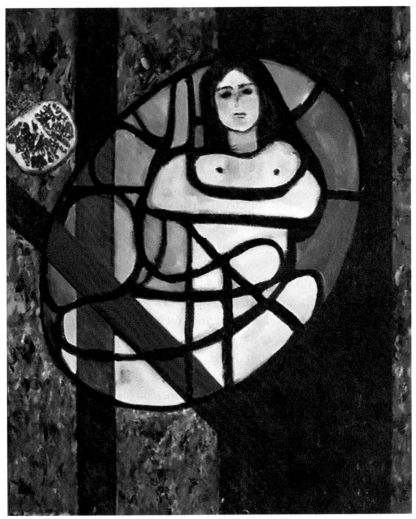

Lilith and the Pomegranate, Linda Greene-Finestone, photographed by Daniel Marchand

Lilith's turn from "first Eve" to she-devil could be seen as a trope that characterizes women's struggle for their needs as partners and mothers versus individuals as a struggle between good and evil. Motherhood is portrayed as binary, although it seldom is in day-to-day life. Mostly, there is a calibrating of needs. Although women care for the needs of others, there is room to balance that with women's own needs. I hope that Lilith's story gives us the courage we may need to be mothers on our terms without being limited by traditional ideals. As we understand

and interpret Lilith's story today, this complex and bold figure can generate inspiration as an icon of equality and female power.

This is reflected in more recent paintings, sculptures and literature, which have portrayed Lilith's sense of agency and strength. She is now being recognized as the first feminist and a modern-day feminist. She is making her mark and telling her story in books and films. The Jewish feminist magazine *Lilith* and the album *Lilith Fair: A Celebration of Women in Music* are named in homage to this symbol of independence.

Lilith

Linda Greene-Finestone

Who is this woman, floating
In a forest, contained
But to emerge from an immaculate ovum.

Her destiny near
Mother of humankind
Adam's first wife.
Elbows already strong,
Face fixed with clarity, impenetrable
Banished from Gan Eden,
Punished for defiance.

Her destiny dashed
Mother of humankind, now
Primordial She-Demon.

The painting *Lilith and the Pomegranate* and poem *Lilith* highlight her plight and the high price she paid for her autonomy. In the painting, Lilith is in a cocoon, floating up from forest soil from which she was created along with Adam. Lilith is alone and cuts a strong figure. Just beyond her grasp is the pomegranate, a symbol of female fertility. As in the accompanying poem, her fate is nothing less than the mother of humankind. But this is not to be. Mounted upon her "immaculate ovum," we see a stamp—a red X—which is a crush on her destiny, evidence of her shunning. Still, her stance is defiant and uncompromising. Her story challenges us to think differently about roles as individuals, partners, and mothers.

Works Cited

"The Alphabet of Ben Sira." *Feminist Philosophy*, https://bccfeministphilosophy.files.wordpress.com/2012/02/lilith.pdf. Accessed 27 Feb. 2024.

Bronznick, Norman Tr., David Stern, and Mark Jay Mirsky. "The Story of Lilith. The *Alphabet of Ben Sira Question #5 (23a-b)*," http://jewishchristianlit.com/Topics/Lilith/alphabet.html. Accessed 27 Feb. 2024.

Trista. "Meet Lilith, Adam's First Wife that Nobody Wants to Talk About." *History Collection*, 26 Aug. 2019, https://historycollection.com/meet-lilith-adams-first-wife-that-nobody-wants-to-talk-about/29/. Accessed 27 Feb. 2024.

"Who Is Lilith?" *Blood, Gender, and Power in Christianity and Judaism*, https://www2.kenyon.edu/Depts/Religion/Projects/Reln91/Power/lilith.htm#power. Accessed 27 Feb. 2024.

2.

queen

Micha Colombo

today I am glorious,
queen of the pavement.
my large-with-life appearance is
magnetic in the crowds. I turn heads and
trigger smiles, cross roads where and when I want to,
and everyone gives way, oh yes, everyone gives way.
women younger, women older give me grins of camaraderie.
I am life, this is life, we can breathe away our boundaries. rolling
round the streets like a giant pea, I don't have a bump, my bump
wears me. I thrill at the trill of you birds up above, I bestow my
smiles upon the people below. I am rich with humanity, brimful
of love, my body will decide on which path I will go. I radiate up
avenues, climbing high beyond the rooftops, and it blazes with a
vastness, this cerulean sky. quiet air, leaning pine and a pop of
fresh mimosa, now my home is getting closer as I rise along the
hill. yesterday was lethargy, nerves, gripes and restless
energy. but today, Sylvia, I too am as 'slow as the world',
like a daffodil unfurled. I do not think. I just am.
this is my kingdom, all are welcome,
this day, today, is mine.

3.

Bringing My Whole Self to Pregnancy

Elana Finestone

The title of this piece is a play on the concept of bringing your whole self to work. To what extent can we bring the facets of our identity into our work as a future mother? What might that look like? In my experience looking at maternity photos, I found the photos to be one-dimensional and not representative of who I was. Photographer Renée Moreau took these photos to help me capture what bringing my whole self to my pregnancy looked like. In contributing these photographs to the book, I invite other pregnant people to reflect on the many parts of themselves they bring to their pregnancy and to welcome them in.

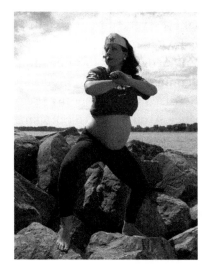

I noticed that so many maternity photos do not capture pregnant people as powerful. Instead, maternity photos often depict pregnant people looking demure and passive. Why were there no images of pregnant people standing in their strength and using their super powers? Posing in this photo, I imagined myself slaying monsters and fighting the patriarchy with my superhuman pregnant strength.

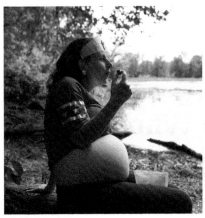 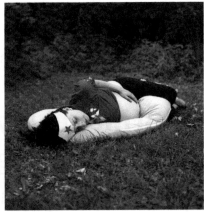

One of the big changes for me in my pregnancy was that I was more tired and hungry than I had been in my entire life. Throughout my life, I had gotten used to powering through tiredness and hunger, but this was no longer an option. I had to make peace with this by reminding myself that even Superwoman needs to rest and eat. Eating and sleeping when I needed to was an act of strength. Chocolate covered almonds (pictured top left) were my favourite pregnancy snack, and for the first time in awhile, I allowed myself to indulge. Once I gave myself permission, which was increasingly more often, I was able to nap anytime and anywhere with my pregnancy pillow (pictured top right).

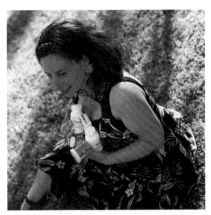

This is me holding all of the kinds of pills I took during my pregnancy: several different kinds of multivitamins and my antidepressant medication. The amount of vitamins prescribed by my doctor increased throughout my pregnancy. At one point, I recall taking four different kinds of vitamins each morning! As a pregnant person, I noticed a pervasive stigma against pregnant people taking antidepressants. To manage my mental health during my pregnancy, I decided to continue using antidepressants anyway. This is a picture of me embracing what works best for me to keep my mind and body healthy.

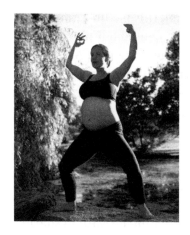

The only form of exercise I was able to continue throughout my pregnancy was yoga. Prenatal yoga gently grounded me and kicked my butt. This is a picture of me doing Goddess Pose (or Utkata Konasana in Sanskrit). The pose made me feel strong and powerful—like a goddess!—when I felt like a tired blob.

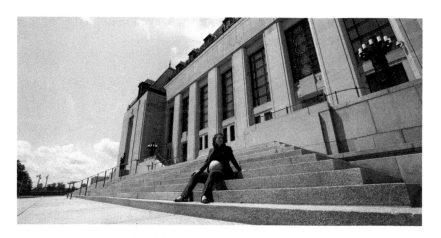

Before giving birth, so much of my identity was tied with being a lawyer. This is me with my pregnant belly sitting on the steps of the Supreme Court of Canada, Canada's highest court. Legs open with a big pregnant belly, this photo is me asserting that as a future mother, I will still belong in the legal sphere.

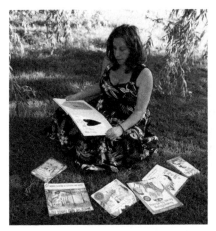

I think this picture sums up my excitement about playing with my future daughter. As an adult, deciding what books to introduce to her was my first foray into the world of children's play. I found this exciting, realizing that I had not engaged in children's play in quite some time and that I missed it. The books on the grass are my favourite books as a child that I was looking forward to sharing with her. The book I am holding is a gorgeous children's book about feelings, given to me by a close friend right after I told her I was pregnant. This book got me excited about the ways I could help her feel emotionally safe in the world.

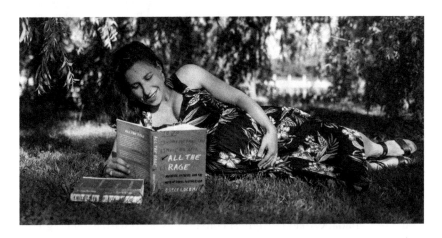

The books I am reading in this picture helped me feel seen throughout my pregnancy. Most of the books I read about pregnancy and motherhood had a condescending tone and engaged in fear-mongering. When I read the books pictured, I felt like a capable woman and became more confident making the best decisions for me and my family. The book I am holding discusses the idea of equal-parenting among partners. This book fostered really important discussions between my partner and I about what we both needed to do to ensure we took on equal loads in our parenting journey.

4.

A Tough Pill to Swallow: Pregnancy, Misogyny, and My Mental Health

Sarah Sahagian

On a frigid January evening, I presented my pharmacist with a prescription. It was for Ativan, a benzodiazepine he'd dispensed several times to me in the past. Normally, when I needed benzos, he didn't bat an eye. I liked my pharmacist precisely because he seemed so detached; he simply put whatever meds my doctor prescribed in a bottle and sent me on my way. The man made no editorial comments or observations about my health; he barely even made small talk. But suddenly, my usually non-plussed pharmacist had lots to say.

"Sarah, I can't fill this prescription for you."

"Why not?" I asked, disoriented. I was meeting my husband for dinner that night. I didn't want to be delayed by an argument with a guy who was supposed to give me the drugs that made my life easier.

"You're pregnant. I don't feel comfortable giving you Ativan. It might not be safe for the baby."

"Do you think I forged the prescription?" I asked with confusion in my voice.

"Of course not!" he reassured me with a sympathetic smile. I read his grin as a condescending act of placation, an expression designed to say he knew I was a nice lady who wouldn't lie. "I know you didn't give me a forgery; I'm just not sure Ativan is safe for you to take right now!"

Was I really hearing this nonsense? "But my perinatal psychiatrist told me I should take it for my panic attacks. Why would she prescribe

it if it were unsafe?" I've always been prone to occasional panic attacks; however, thanks to a freak pregnancy complication that led to the loss of one of my kidneys in my second trimester, I'd begun experiencing them a few times a week. I would have no idea when these panic attacks would occur. But they were so debilitating, I sometimes refused to leave the house. When I relayed this information to the perinatal psychiatrist, she insisted there was no reason for me to suffer. So, she prescribed the pills.

Perinatal psychiatrists are doctors who specialize in advising pregnant and postpartum people on how to navigate mental health struggles. Surely this man, who was not a trained perinatal shrink, couldn't think he knew more than that sort of specialist! Or did he?

He did.

"Sarah, I'll call your doctor, and we'll discuss it together. I have some questions."

My pharmacist had just announced he planned to mansplain a pregnant woman's mental health to someone who'd devoted three decades of her life to studying and treating pregnant people. Of all the mansplaining I've encountered—and like most women in their thirties I'd heard a lot—this was the most blatant male hubris. Now, I felt small, disempowered, and worse yet, I still needed that Ativan...

Instead of telling my pharmacist he was an unprofessional misogynist, I walked out the door in tears. The feminist inside me, who is located at the core of my being, wanted to stand in front of him in righteous fury. That part of me wanted to make a scene, to call the Ontario Association of Pharmacists on the spot and complain about his sexism in the middle of the store. If he was going to ruin my day and ignore my mental health needs, why should I make it easy for him? Instead, I stood there, outwardly polite and complying. Inwardly, I was using all the four-letter words.

Like so many women, I've been trained not to take up too much space. Today, the demure woman the world wanted me to be overpowered my feminist impulses; I worried fighting with my pharmacist's paternalism would take too long and waste the time of the kind strangers waiting behind me. I imagined my fellow customers were nice people who just wanted their antibiotics or cholesterol pills. Surely, they didn't want to end up in the middle of a pregnant lady's quest for justice. Most of all,

I feared the other patrons would think I was some sort of hysterical pregnant woman—the idea of that was too much for my gestating guts to stomach.

On the subway that night, I hunkered down on the special "blue seats" the TTC reserves in part for pregnant folks. Through my tears and exhaustion, I was reminded of something I'd read in graduate school. It was a quote from radical feminist Adrienne Rich's book *Of Woman Born*: "There is nothing revolutionary whatsoever about the control of women's bodies by men. The woman's body is the terrain on which patriarchy is erected" (Rich 55).

Rich is a feminist theorist who passed away in 2012. Because of her well-documented penchant for transphobia (Mukhopadhyaya), I rarely revisit her work. As binarist as Rich's thinking was, there was something about this particular argument that spoke to my experience: that pharmacist's actions were the result of thousands of years of Western patriarchy, a system that emboldens men to believe they know what a woman needs better than her highly qualified doctor. And it goes without saying they know better than the woman herself.

That night, I dusted off my copy of Rich's manifesto on the oppressive nature of motherhood as an institution. *Of Woman Born* is a complicated text, one that simultaneously enrages and comforts me. Rich argues sex and gender are synonymous. Not surprisingly, *Of Woman Born* insists we are "all born of women" (Rich 57), a sentiment that erases the experiences of nonbinary people who gestate. Yet what Rich explains so clearly is how pregnancy—the ability to grow another human in one's body—is an experience that sounds as if it should be empowering; however, it has historically been a site of oppression.

Rich argues, "Female possibility has been literally massacred on the site of motherhood" (60). One reason for that death of possibility is her observation that "Most women throughout history have become mothers without choice" (60). Indeed, before reliable birth control methods, pregnancy was a profound risk for anyone with a uterus. But even in the twenty-first century, we know motherhood is not always consensual. We hear in the news about politicians (and Supreme Court justices) who wish to restrict access to birth control and abortion.

Beyond issues of reproductive freedom, many of my girlfriends have confided in me that they felt pressure to reproduce. Society loves nothing more than to festoon magazine covers with the compact, second-

trimester bumps of pregnant celebrities. And everyone from aunts to Uber drivers loves to remind a childfree woman in her thirties that "the clock is ticking"—an idiom that is always applied to baby-making but never applied to how time is also running out to write one's first novel or backpack through Europe.

Novelist Sheila Heti distills the societal pressure on those coded as women to have babies like this: "It seemed to me like all my worrying about not being a mother came down to this history—this implication that a woman is not an end in herself" (148). With a world like that— one where a woman without a child is perceived as a fish without gills (to reference and rewrite Gloria Steinem)—it begs the question, is pregnancy ever truly a choice? And even if it is, doesn't the norm of a patriarchal society that surveils pregnant women's bodies and restricts their freedoms mean that everything that comes after choosing to get pregnant is not truly a choice?

In a 2013 op-ed for *The Wall Street Journal*, economist and parenthood researcher Emily Oster reflected on her experience with pregnancy: "Being pregnant was a good deal like being a child again. There was always someone telling me what to do." Reflecting on the public surveillance of her body, Oster observes, "It started right away. "You can only have two cups of coffee a day." I wondered why. What did the numbers say about how risky one, two or three cups were?" As Oster's research in her 2013 book *Expecting Better* demonstrates, proven statistical risks have little to do with societal expectations for how we should navigate pregnancy. In my experience, nowhere is this truer than perinatal mental health.

Before conceiving my daughter, I spent a considerable amount of time researching how to have a healthy pregnancy. At the time, I lived with three diagnosed chronic mental illnesses: persistent depressive disorder, generalized anxiety disorder, and complex PTSD. In 2017, my GP prescribed me Wellbutrin, a class of antidepressants known as a dopamine reuptake inhibitor. Suddenly, I had a new lease on life. I transformed from a woman so drained I feared I'd accidentally drown in the bathtub to someone who went to parties and hung out with her friends at pubs.

As privileged as I was to find an effective antidepressant, I worried my desire for a baby was incompatible with the medical treatments I used to manage my mental health problems. But the fact remained: I'd wanted a baby since I was a baby! When I was five years old, an aunt

asked how many children I intended to have when I grew up, and I gleefully declared, "Four!" The idea that I would one day be a mother was the foundation for all my daydreaming about adulthood. I had plenty of dreams throughout my youth—to write, to see the world, to attend graduate school, to find romantic love; however, the baby was the thing I found most compelling.

In my twenties, I flirted with the idea of remaining childfree, but the considerable benefits, including more leisure time, a less expensive, more environmentally-friendly lifestyle and more time to work, never fully outweighed my desire to start a family. In the spring of 2019, it was with some trepidation that I made my first appointment to visit a perinatal psychiatrist. I wanted to see if my mental health could withstand the arrival of a child.

My entire life, I'd been exposed to ableist images of mothers living with mental illness. These mothers invariably scarred their children for life. In 2008, I sat down with my roommates one Thursday night to watch our favourite show, *Grey's Anatomy*. Together, we watched spellbound as the protagonist, Dr. Meredith Grey, tells her therapist about a childhood memory that makes her feel unable to love Dr. McDreamy, the obvious man of her dreams. In this memory, her mother, Dr. Ellis Grey, is suicidal over a breakup with her lover. Distraught, Ellis slits her wrists in front of a preschool-age Meredith. Young Meredith miraculously remembers how to call 911, saving her mother, but leaving herself with a lifetime of trauma to unpack (Shonda Rhimes).

Was this TV show saying it was a bad idea for people like me— people prone to depressive episodes and big emotions—to have kids? Was I destined to turn out like Ellis if I did?

More recently on *Mare of Easttown*, Mare's daughter-in-law Carrie spends the limited series trying to prove that her schizophrenia diagnosis does not prevent her from being an attentive mother to her son. The show, however, begs to differ. On one occasion, she falls asleep while supervising her child's bath, leading to a dramatic scene where she believes he's drowned (Ingelsby). Carrie, who also wrestles with a drug use disorder, ultimately relapses and abandons the quest to regain custody of her son. Instead, he stays with Mare, the titular character and grandmother who does not take medication for a mental health problem. (Ingelsby).

The subtext of popular depictions of moms living with mental illness

is this: No matter how hard we try, we're not fit. The message is ubiquitous, so it's hard not to believe it.

I prepared for the appointment with my perinatal psychiatrist like it was a job interview. I blew out my hair and wore a classic floral dress I hoped said, "I'm not too crazy to have a baby!" I wore flats instead of heels because I didn't want the shrink to think I was unprepared to run after a toddler at the grocery store.

My preparations were meticulous, but the appointment was comparatively easy. The doctor was downright cheerful about my prospects of having a healthy baby. I was shocked. According to her diagnosis, it was entirely safe for me to be a parent. I was about to celebrate when a terrifying thought grabbed me. "But will I have to stop taking my medication?" I asked.

I'd always assumed pregnancy would require me to sacrifice my mental health, to destroy my sanity to protect my baby. But in the words of a psychiatrist who treated me, "Your mental health matters at least as much as the health of your future baby."

I wouldn't have to stop taking the medication. Over the rest of the session, my doctor walked me through the risks of taking Wellbutrin, an antidepressant, during pregnancy. She explained research showed the risks were minimal. Admittedly, this isn't true of all antidepressants, but I was surprised to find it is indeed possible to be a gestating person who continues to take her medication—and for your doctor to sanction that decision.

Sure, there were some risks associated with my Wellbutrin use. For example, taking Wellbutrin is associated with a higher likelihood a fetus will have ADHD, but the overall risk is still low (MGH Centre For Women's Mental Health). Given the risks of discontinuing my antidepressants to me (the return of a depression so debilitating, I couldn't get out of bed), the risk absolutely felt worth taking. As it turned out, protecting my mental health was not mutually exclusive with pregnancy. I went home and enthusiastically conceived the baby I'd always wanted.

Around eight months later, in my last trimester, I was once again relieved when my perinatal psychiatrist saw fit to prescribe benzos. She assured me the drugs did not pose a serious risk to my fetus and reassured me the drugs could help me cope with the remaining weeks of gestation.

By the time I was given this prescription for Ativan, I had endured a traumatic pregnancy, which included debilitating hyperemesis

gravardium, three threatened miscarriages, and the loss of one of my kidneys. In my shrink's office, I told her I was so overwhelmed by my frequent panic attacks that I didn't believe I could get through the last few weeks of carrying my daughter. I couldn't sleep and I was experiencing regular suicidal ideation. My mind and body kept asking me, "When will something else go wrong?" The benzos, however, promised relief from an anxiety that overcame me so often that I'd forgotten what it was to relax. The prescription gave me a tinge of hope when I received it, and that hope was dashed by a male pharmacist who didn't care about me, only the baby inside me.

Today, I am the proud mother of a two-year-old. I have not been a parent long, but I can confidently say that, in my case, the reason why it is so difficult to have a child as someone with mental illness has more to do with a society that devalues mothers' mental health than the work of gestating or raising children.

The scientific truth that the benefits of antianxiety medication to me outweighed any risks to my fetus is lost on some. A cost-benefit analysis regarding medication during pregnancy is only compelling to people who care about the costs and benefits to pregnant people. My pharmacist cared about my fetus more than he cared about me in my female presenting body. He cared more about hypothetical—and unlikely—risks to a hypothetical person inside me than he did about me, a client of a decade. The message was clear: In patriarchal thinking, a mother's wellbeing doesn't matter.

It's been more than two years since my former pharmacist refused to fill my prescription. When I relayed the story to my friends, some suggested I return to confront the misogynistic pharmacist. However, his pharmacy closed during the COVID-19 lockdown that began a month after I gave birth.

I'll likely never see that pharmacist again. However, I harbour a fantasy, a daydream of what it would have looked like, had I fought his decision to deny me the pills I needed. In my imagination, I stand up as straight as my heavily pregnant form will let me. Next, I ask, "Why don't you care about pregnant people?" The fantasy ends there because I'm not sure what his answer would be. I'm not even sure he'd seriously consider the question. But I wish I'd asked it.

When you're a woman or a nonbinary person, people are going to call you hysterical anyway. You might as well put up a fight.

Works Cited

Heti, Sheila. *Motherhood*. Alfred A. Knopf, 2018.

Ingelsby, Brad. "Sore Must Be The Storm." *Mare of Easttown,* season 1, episode 6, HBO, May 23, 2021.

Ingelsby, Brad. "Sacrament." *Mare of Easttown,* season 1, episode 7, May 30, 2021.

MGH Center for Women's Health. "Exposure to Antidepressants During Pregnancy and Risk of ADHD In the Offspring." *Reproductive Psychiatry Resources and Information Centre,* 12 May, 2012, https://womensmentalhealth.org/posts/exposure-to-antidepressants -during-prenancy -and-risk-of-adhd-in-the-offspring/. Accessed 19 Feb. 2024.

Mukhopadhyay, Samhita. "Was Adrienne Rich Anti-Trans?" *The American Prospect,* 16 April 2012, https://prospect.org/civil-rights/adrienne-rich-anti-trans/. Accessed 19 Feb. 2024.

Oster, Emily. "Take Back Your Pregnancy." *The Wall Street Journal,* 9 Aug. 2013, https://www.wsj.com/articles/SB10001424127887323514 404578652091268307904. Accessed 19 Feb. 2024.

Rhimes, Shonda. "Freedom, Part 2." *Grey's Anatomy,* season 4, episode 17, ABC, May 22, 2008.

Rich, Adrienne. *Of Woman Born: Motherhood as Experience and Institution.* W.W. Norton and Company, 1976, New York.

Maternity Photography: Beyond the Gender Binary

Clara Kundin

I did not enjoy pregnancy. Though pregnant by choice (and certainly happy enough as a parent now), I struggled through each of the nine months, appalled by how my body was changing and becoming alien to me. While the painful moments of sciatica and the way my gums bled from lack of nutrients were hard, harder still was the transformation of my breasts and stomach into new, larger shapes. I had always been fairly at ease in my skin, perhaps more so than the average person, so the sudden disgust in my own body was new and shocking. I felt monstrous, uneasy in my skin, during a time when I was supposed to be revelling in the magic happening in my body.

While I would not have used the word "fat" to describe my pregnant body, I'm sure part of my new aversion to it was influenced by internalized fat-phobia, the growing size of parts of my body triggering feelings of anger at myself. I think much of my disgust for my form was also due to my cultural understanding of the pregnant body as something grotesque. Mikhail Bakhtin emphasizes the maternal body when he describes the body as grotesque:

> The grotesque body, as we have often stressed, is a body in the act of becoming. It is never finished, never completed; it is continually built, created, and builds and creates another body. Moreover, the body swallows the world, and, is itself swallowed by the world (let us recall the grotesque image in the episode of Gargantua's birth on the feast of cattle-slaughtering). This is why

the essential role belongs to those parts of the grotesque body in which it outgrows its own self, transgressing its own body, in which it conceives a new, second body: the bowels and the phallus. (qtd. in Dentith 226)

The material way my body was visibly and rapidly changing in front of my eyes was a sign of my body in the process of becoming. Pregnancy, this act of becoming, while often called "beautiful," was more often treated as something monstrous, something grotesque. As someone who made a living using my body as my medium, I felt the transformation of my form perhaps more keenly than many. I continued to experience this grotesque understanding of my body throughout my pregnancy, particularly in my work.

Before conceiving, I worked as a theatre-maker and art model in New York. Like most pregnant people, I attempted to continue my work while pregnant. I immediately lost most of my acting opportunities, as directors did not seem to want to risk casting a pregnant person, but my work as an art model exploded. I was in demand as a model for art classes and private photographers. Everyone wanted to capture the pregnant form. Because of this, I participated in around thirty maternity photo shoots, an absurd number for the average pregnant person. Generally, the purpose of a maternity shoot is to celebrate the beauty of the pregnant person (usually a woman) or to highlight the growing life inside. Photographer Clay Blackmore describes his maternity sessions: "The session lasts about 30 minutes and offers genuine engagement with the camera, respects the comfort zone of the mother, and focuses on the child inside the subject. It's one of the most beautiful ways a woman can be portrayed" (6). This goal was impossible for me, however, as someone who not only felt distinctly not beautiful but was also participating in the photo shoot as a paid model.

The (mostly male) photographers were remarkably enthusiastic about working with me. Modelling can be a fairly cold or detached business. You are hired for your body and expected to do what is asked of you. I found that while I was pregnant, however, photographers were uncharacteristically thoughtful, offering me breaks and accepting my limitations in a way that usually would have been met with conflict. All of the photographers expressed a desire to make me feel beautiful and wanted to take photos that would make me feel empowered. Despite being a hired professional, photographers treated me not as a model but as

a client who wanted the traditional empowering maternity shoot experience.

That was, of course, impossible. Not only was I not capable of feeling beautiful, but the idea of what a maternity photo was supposed to look like stood in the way of me coming anywhere close to feeling empowered. Because I was hired to do what the photographer asked, I did not push back against their concepts for each shoot. I have more photos of pregnant me looking angelic and passive than I know what to do with. When I wasn't posing with my hands gently clasping my belly while I gazed demurely at my stomach, I was asked to look sexy. One particularly humiliating shoot where I was draped seductively over a motorcycle still haunts me. None of these photos empowered me. I was always the object of the male gaze, either sexualized or removed of personality; the camera was more interested in what was growing inside of me. While I was gaining financially from this endeavour, I felt disempowered and misrepresented in my maternity experience.

In her seminal essay *Visual Pleasure and Narrative Cinema*, Laura Mulvey coins the idea of the male gaze, describing film's tradition of using "the image of woman as (passive) raw material for the (active) gaze of the man" (qtd. in MacKenzie 540). While Mulvey makes her argument using cinema, the presence of the male gaze is identifiable in print photography. Within maternity photography, a stated goal of empowering the pregnant subject becomes impossible within the context of the male gaze. By definition, the female subject becomes passive material, not the centre of her experience. Even my maternity shoots with a few female photographers suffered from the dominant narrative of what a maternity photograph should be due to the dominant, male-gaze-driven industry. While women did not sexualize me with their photos, I was always represented as passive and beautiful. I treasure some photos women created of me due to their aesthetic value. Two hang on my wall next to me as I write. But the photos do not represent my pregnancy experience, only another's perceived idea of my beauty. Thus, these photo shoots also fell short of the intended goal of empowerment.

This dominant style of maternity portraiture has both a long and relatively brief history. In a 2020 show at the Foundling Museum in London, curator Karen Hearn attempted to trace the history of maternal portraiture; her interest was piqued after working on a display of Flemish artist Marcus Gheeraerts II, whose work included a portrait of a

pregnant woman, *Portrait of an Unknown Lady*, ca. 1595 (Al Jamil 156). The pregnant woman in this painting strikes a pose familiar to our modern expectation for maternal posing: She stands with her hand on her belly to highlight her stomach's curve and the life inside. Hearn's exhibit spans from the 1500s to 2017, ending with Awol Erizku's photograph of Beyoncé, pregnant with twins, which was the most-liked photo on Instagram of that year (Katz 2020). Hearn showcases how pregnancy was rarely depicted in art before the 20th century, but it wasn't until 1991, when Annie Leibovitz's photograph of Demi Moore, nude and seven months pregnant, appeared on the cover of *Vanity Fair*, that attitudes towards pregnant bodies shifted.

George Lois describes the photo of Moore as "an instant culture buster" that would upset those who found the pregnant female body "grotesque and obscene," echoing Bakhtin's identification of the maternal as grotesque (Lois 2011). In the photo, Moore stands gazing away from the camera with one hand covering her breasts and another holding her belly, in a pose we recognize as classically maternal. It echoes the woman's pose in the Gheeraerts painting, though with less clothing. Moore looks beautiful: her hair is styled, and her hand and neck are bejewelled. Since Leibovitz was combating negative attitudes towards pregnant bodies, this pose and styling make sense. Since 1991, that pose and style of maternity photography, however, has remained constant. Returning to the ending photograph in Hearn's exhibit of Beyoncé, we see the same pose: hand on stomach. While not nude, she is dressed in sexy lingerie and surrounded by flowers. She looks both serene and sexy. *Smithsonian Magazine* sees this portrait as a step forward for women: "As Beyoncé's portrait suggests, modern women are taking unprecedented agency over their pregnant bodies, celebrating this phase as a time of beauty and empowerment" (Katz 2020). But what of the woman or pregnant person who does not feel empowered by pregnancy? A Google search of maternity photography reveals thousands of images of primarily white women in similar poses to Moore and Beyoncé. Alternatives are limited to comic tropes of the "fat husband" mimicking a pregnant belly or *Alien* movie references. I wanted a way to capture how I was feeling about my pregnancy, something to hold up as representative of my frustrations with the experience.

On a tour to Boston to work with a few other photographers (resulting in an erotic series of up-close photos of my "pregnant" clitoris and

one shoot in a lake where I was eaten alive by sand fleas—how empowering!), I reached out to a photographer and friend, Sheri Furneaux. Sheri is a trans nonbinary photographer whom I'd worked with several times before. I first met them in 2018 when they took me on a wandering shoot in downtown Boston and created some uniquely beautiful photos capturing the colours of the downtown area in a way that delighted me. I regularly stayed with Sheri when I travelled to Boston, and they became the artist I turned to when I wanted to make something ugly and beautiful. Sheri never batted an eye when I suggested a photo of me with noodles hanging out of my mouth or letting coffee drip from my tongue back into a cup. I trusted Sheri to be able to capture what I felt about my pregnancy—something monstrous—but to do so in a way that was somehow still beautiful.

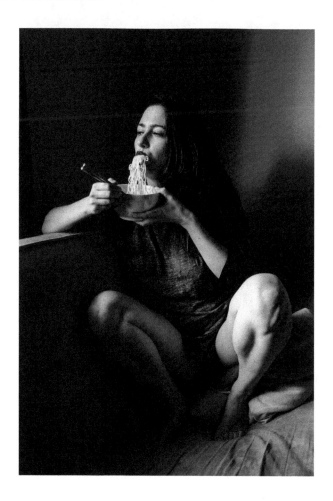

During my stay with Sheri, I asked them to take a photo of me lounging on a bed and eating snacks. We scoured their fridge and found a tub of ice cream to use as a prop. I wore the unmatched maternity bra and underwear I had slept in and added a bathrobe. I stared directly at the camera. We created a highly staged photo that felt like a snapshot of life: Sheri's specialty. In the picture, I am distinctly pregnant and appear to have been interrupted in a private moment. I glare at the camera as if to ask, "Why are you here?" I am tired and unhappy yet because of Sheri's unique gaze, the photo is still beautiful. The lighting is soft, the colours muted. My stomach is present but the focus of the photo is on my eyes, not on the life growing inside me. I became the wild mother through Sheri's eyes. Without projecting too much into Sheri's psyche, I believe that their perspective as someone outside the gender binary made the subtlety of the photo possible. Male photographers wanted to sexualize me, and female photographers wanted to soften me. Sheri found a way to show-case at once the hard, soft, and grotesque of my pregnancy experience.

After Mulvey identified the dominant male gaze in cinema, there began a movement to upend it. Mulvey herself notes that radical film-makers had already begun to "free the look of the camera into its materiality in time and space" (qtd in MacKenzie 542). Theorists began to discuss the possibility of the female gaze in cinema and beyond. As alternative gender expression has become more accepted and mainstream, discussions of the "trans gaze" or the "nonbinary gaze" have made their

way into popular discourse. *The Luupe*, a content creation and marketing site for large brands founded in 2019 published an article describing how the "nonbinary gaze" is "changing the face of commercial photography" (Dallas), indirectly referencing Mulvey's essay as the source point for discussions about who is behind the camera lens:

> Since the late 1970s, it has become common to talk in depth about the female and male gaze in art, advertising, film and photography. In recent years, as non-binary and transgender creators gain more visibility in the media, pop culture and the photographic industry, space is opening up a new way of seeing. A beautiful celebratory "non-binary gaze" is taking form and making itself known. (Dallas)

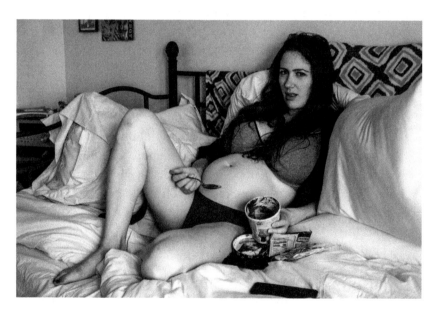

In the article, photographer Liam Woods explains the nonbinary gaze as such:

> My gender expression helps me view the world with an open heart and fresh perspective. I believe my own gaze differs as a Trans/Non-binary person because we have an understanding of how valuable it is to break out of the binary. When I apply it to my work, it can create a rich, diverse, colorful atmosphere of so many possibilities. (qtd. in Dallas)

Woods makes it clear that their identity as a trans nonbinary individual is integral to how they create art.

When I asked Sheri to take maternity photographs of me, I was not consciously seeking a nonbinary photographer to take photos of me, a cis woman, that would make me feel seen. I was merely initiating collaboration with an artist and friend whose work I admired. It wasn't until after I was so moved to see the photos that I began to reckon with why the experience and the photos were so evocative. In preparation for this article, I spoke with Sheri about how they interpreted our photo shoot and their place as a nonbinary person behind the camera lens. For Sheri, the difference between the male gaze and the nonbinary gaze is in how the subject of the photograph is viewed. They link the male gaze with "gazing at a person like they are an object or a piece of the set" in contrast with "looking at a person like they're a part of a piece of art." Sheri identifies the male gaze with commercialism in photography, a set-up that reduces a model to an object.

Sheri's particular identity with femininity within their nonbinary identity also affects their experience as a photographer:

> I'm always trying to define what femininity can mean because I relate so much to my femininity. I'm a feminine person. And that presents challenges in the queer community. It's androgyny or bust. I work with a lot of people who identify as trans or non-binary but a good portion are just women who want to be seen. There's an intersection we don't recognize a lot with our cis female allies. We're all in the same boat. It's like I see you and I recognize that you've struggled.

As I drafted the abstract for this essay submission, I worried about my perspective as a cisgender woman writing about this subject matter. Sheri articulates why the two of us connected while making these photos: we are both people who want to be seen. I sought out Sheri to take my maternity photos because they had made me feel seen in our previous work together.

As Sheri and I conducted our interview, they answered my questions in ways that surprised me. I think I was looking for responses that would neatly fit into my thesis for this chapter. But reality is not neat, and Sheri made it clear that their identity and experiences shaped their work making these photographs in many ways, not just about their gender

expression. They described working on previous maternity shoots with the same intention of making art of their subject but the resulting photos had not been as meaningful as what we created. Sheri described the unique perspectives and points of connection in our shoot and relationship: "But the way that you hated being pregnant, and the way that we're close, you're a friend, that lens of vulnerability connect[ed] me to my relationship with my mother. She hated pregnancy. She wasn't ready to be a parent. Because of my life, I think of moms so much more as real people." Sheri highlights that there was a two-way vulnerability being shared in our work together due to my current state of pregnancy and their complicated relation to motherhood. Our intersecting resentment helped us find common ground to make a more complex piece of art. This complicates my desire for a simple thesis of how their non-binary perspective influenced the photos but perhaps speaks to how gender and motherhood are complicated and cannot be reduced to simple topic sentences, much as I would like to try.

Sheri's perspective on our work together indicated a move beyond the notion of gaze, nonbinary or otherwise. Gaze feels one-directional, moving from the photographer or viewer to the model, object, or subject. Sheri and I created through reciprocal exchange, negating the possibility of the gaze. I sought out Sheri because they made me feel seen. In this shoot, we saw each other. Perhaps the nonbinary gaze is not a gaze at all but something closer to the reciprocal noticing of identity. Liam Woods describes their work as breaking out of the binary. Perhaps that breakout is breaking out of the form of gazing itself.

Because Sheri and I trade photos in a mutual exchange, we always take some more traditionally beautiful images to offset my avant-garde ideas—photos that are more easily marketable for their portfolio. Yet even in our more classic maternity shoot, where I am nude and my belly more pronounced, I see my humanity underneath. I look directly at the camera, and I hold not my belly in protection but my breasts, hiding them from the camera and the viewer's gaze. Sheri managed to capture a hint of anger and pain in my eyes, and the veins in my legs and stomach are pronounced. The photo is distinctly human, not an image of maternal, pregnant perfection. In this image, I am truly wild with child and perhaps even empowered through my anger.

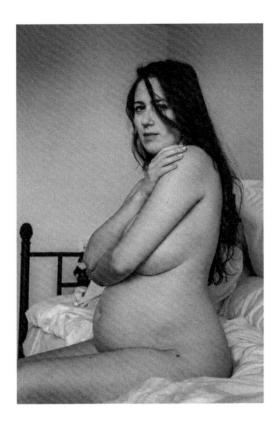

When I posted these photos on the Instagram account I used for mod-
elling, the response was noticeable. While I certainly did not reach
Beyoncé-level engagement with my modest following, these two mater-
nity photos remain in my top three most-liked photos to date, each
receiving over 900 "likes." For comparison, the maternity photograph
I posted from the referenced "sand flea" photo shoot on a beach received
only 344 "likes." I chose not to post the photo of me nude on a motor-
cycle. While "likes" alone certainly indicate viewer engagement, what
is more notable about each of these photo posts is the level of engagement
via comments. On the beach shoot, twelve people commented, a typical
response to my posts. On Sheri's photo of me nude on the bed, fifty-one
people commented. On the photo of me eating ice cream, sixty-three
people responded. The comments on the nude shoot are mostly reflec-
tions of my beauty. One commenter, a photographer himself, stated only
"MATERNAL GLOW." I look at this photo and see how it breaks
traditions, see the anger in my eyes. But our goal with that picture was

to make a more traditional maternity photograph and the comments reflect that it was seen in that light.

The responses to the image of me eating ice cream are more complex. There are typical heart emojis and statements of beauty, but people also responded with laughter. Others responded with excitement. One commenter, another male photographer said, "I would say in your condition, you can show what maternity is really like"—a response that I find amusing, as he feels the need to permit someone else's artistic output. Many people responded in celebration. Positive comments— such as "I can't express how much I love this"; "I'll echo everyone else. These shots are BRILLIANT!"; These are honestly my favourite maternity shots I've seen I love these"; "Oh my god, I love this though!"; "Brilliant"; "I fucking love this"; "Yasss this is perfect" and "Best maternity shoot ever?"—were common. The responses indicate a hunger for a new type of maternity photography that goes beyond simply showcasing the beautiful or sexy pregnant form.

This chapter is, of course, a celebration of Sheri's skill as a photographer, but I also attempt to offer a possibility for a new way of approaching maternity photography, not as an image that glorifies the pregnant body but as an attempt to capture the complexity and perhaps grotesqueness of it. Sheri's perspective outside the gender binary made that possible in their images of me, but other outsider perspectives in this industry might similarly disrupt it. Rihanna's recent maternity announcement photos, taken by fashion photographer Miles Diggs, shook popular media because the photos were distinctly unmaternal. She wears streetwear and looks at the camera, hands in pockets not on her belly. Diggs's Instagram showcases hundreds of celebrity fashion photos where clothing and attitude are on display; there is nothing soft about his work. His outsider perspective on maternity photography allowed Rihanna, someone who celebrates fashion and attitude like few others, to continue to showcase those attributes, keeping her wild personality front and centre while announcing her pregnancy. I hope that more photographers will attempt to capture what is unique about the pregnant person, capturing their personality, instead of trying to soften or sexualize the subject or placing the growing belly as the most important part of the pregnancy experience. The response to my work with Sheri and Rihanna's photographs indicates a craving for more diverse and real representations of pregnancy. Photographers can shift

the perspective of the photo from aspirational to representational by, as Sheri calls for, viewing the subject as art, not an object. In doing so, maternity photography might begin to empower the pregnant subject by showcasing their humanity.

Endnotes

1. Because Sheri is a friend, I referred to them as Sheri in this article instead of the more formal last name structure of academic writing.

Works Cited

Al Jamil, Miriam. *Review of Portraying Pregnancy: From Holbein to Social Media, by Karen Hearn. Early Modern Women*, vol. 15, 2020, pp. 156-58.

Blackmore, Clay. "Lighting Maternity Portraits: How to Stay in the Mother's Comfort Zone." *Studio Photography*, vol. 9, no. 9, 2006, 6. ProQuest, http://login.ezproxyl.lib.asu.edu/login?url=https://www-proquest-com.ezproxyl.lib.asu.edu/magazines/lighting-materni-ty-portraits-how-stay-mothers/docview/231983867/se-2.

Dallas, Desdemona. "How the Non-Binary Gaze Is Changing the Face of Commercial Photography." *The Luupe*, https://theluupe.com/blog/how-the-non-binary-gaze-is-changing-the-face-of-commercial-photography. Accessed 24 Feb. 2024.

Dentith, Simon. Bakhtinian Thought: *Intro Read*, Taylor & Francis Group, 1995.

Furneaux, Sheri. Interview. Conducted by Clara Kindin. 14 Sept. 2022.

Katz, Brigit. "The Evolution of Pregnancy Portraits, from Tudor England to Beyoncé." *Smithsonian Institution*, 21 Jan. 2020, https://www.smithsonianmag.com/smart-news/exhibition-spotlights-500-years-pregnancy-portraits-180974021/. Accessed 24 Feb. 2024.

Lois, George. "Flashback: Demi Moore." *Vanity Fair*, 22 June 2011, https://www.vanityfair.com/news/2011/08/demi-moore-201108. Accessed 24 Feb. 2024.

Mackenzie, Scott, editor. *Film Manifestos and Global Cinema Cultures: A Critical Anthology*. University of California Press, 2014.

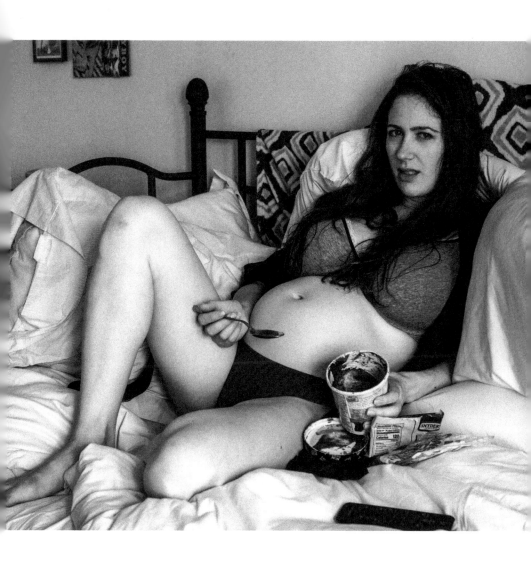

PART II.

BIRTH

6.

We're Badass Moms: A Narrative Inquiry into Women's Experiences of Pregnancy and Delivery during the COVID-19 Pandemic

Andrea DeKeseredy

Introduction

As Canada tries to recover from the COVID-19 pandemic, little attention has been given to women who were pregnant during the pandemic. Like so many others who went through the pandemic, pregnant women's experiences were lost among the goal of "getting back to normal." Through ever-changing hospital policies, socialization restrictions, closure of childcare facilities, and the increased risk from the virus, pregnant women's lives were affected in irreversible ways. While the unexpected challenges of the pandemic were daunting, navigating them allowed women to recognize newfound strength and maternal power.

In this chapter, I present the stories of four Canadian women who were pregnant during the pandemic: Effie, Louise, Joan, and Stella. In sharing their stories, we can better understand what life was like for

pregnant women during the virus outbreak and acknowledge their strength in making it through.

The Pandemic and Pregnancy

The COVID-19 pandemic and the government's attempt to contain the spread of the virus upended the lives of nearly everyone living in Canada. Many pinpoint the pandemic's beginning to be March 2020 when multiple provinces had cases, community spread had occurred, and restrictions had been implemented to try and mitigate the spread of the virus (Canadian Press). For Canadians, these restrictions included school and daycare closures, the cancellation of events, travel restrictions, mask-wearing, and limitations on how many people could gather (Canadian Press). Confusion, fear, and anxiety permeated the lives of those trying to navigate the uncertainty of an ever-changing national crisis. Throughout the initial phase of the pandemic, three million Canadians experienced job loss, and a quarter of Canadians fell into poverty ("Economic Impacts"). Canadian women were disproportionately affected by the pandemic, as they were more likely to reduce their hours at work and leave their jobs (Fuller and Qian 213).

The COVID-19 pandemic had a significant impact on the lives of pregnant women, and for many, it shaped the entirety of their pregnancy experience. Those who navigated pregnancy during the outbreak of the virus experienced anxiety, fear, extreme isolation, and abandonment due to their worries about contracting the virus and the mitigation strategies (Rice and Williams 559; Kolker et al. 4). Pregnant women had little added support during this time and had difficulty accessing routine medical care (Altman et al. 4; Rice & Williams 559). Many women felt that the quality of their prenatal care had been compromised due to changes made to healthcare services (Altman et al. 4; Rice and Williams 559). Confusion and misinformation regarding COVID-19 vaccines and pregnancy caused further stress for those managing their health while carrying a baby (Anderson et al. 5). After birth, mothers reported having difficulty bonding with their baby and noted a profound sense of loss regarding what their pregnancy could have been (Ollivier et al.; Kolker et al. 4). In their early postpartum weeks, new mothers continued to live in isolation, navigating the challenges of raising a new baby alone (Ollivier 4).

While academic research has begun to explore the lived experiences of pregnant women after the outbreak of the virus, much of the conversation surrounding the pandemic focuses on "getting back to normal." Little attention has focused on the experiences of pregnant women, who were heavily impacted. This chapter aims to bridge the gap and tell the stories of those who manoeuvred pregnancy during this tumultuous time.

Crafting the Participants' Stories

This chapter centres on the participants' voices and creates a space in which they can tell their stories in a representative way leading to a better understanding of their experiences. Therefore, the article is rooted in narrative inquiry, which is a collaborative form of qualitative research used when the researcher wants to understand better someone's experience (Clandinin and Connelly 20). It is the process of telling, reliving, and retelling the experience of a person's life (Clandinin and Connelly 20). Put simply, "narrative inquiry is stories lived and told" (Clandinin and Connelly 20).

Ethics approval for this project was obtained through the University of Alberta Research Ethics Board. I sought participants who self-identified as pregnant Canadian women between the dates of March 2020 and December 2021. To recruit participants, I created a digital image that stated I was looking to speak to people who were pregnant during the COVID-19 pandemic. I posted the recruitment material in two places: my Twitter account and Facebook page. Despite my small social media presence, the response I received was overwhelming, and I received dozens of inquiries from women who wanted to share their stories with me. Each of the participants read and signed an informed consent form before participating in the interview. In the end, I spoke to four women from Alberta, Canada. I used Zoom to avoid any risk of spreading the virus and worked around the participant's schedules as new moms. A conversation guide was used to interview my participants about their experiences.

After completing the interviews, I listened to the audio recordings before transcribing them verbatim. I then engaged in a "narrative smoothing," in which I took each interview and formed them into a cohesive narrative. I sent each transcript to my research participants for

them to read, give feedback, and choose a pseudonym. To analyze the interviews, I first arranged my participants' stories in a way that showed the significance of their experiences and allowed the reader to understand them better—a narrative form of analysis (Kim 197). Second, I used a paradigmatic form of analysis to briefly discuss the themes present throughout each of the participant's stories (Kim 197). While each of the women had a unique experience during the pandemic, many common themes emerged in their stories. Most predominantly were examples of maternal strength.

Effie's Story

Effie is a thirty-five-year-old married administrative assistant. She has one child, a daughter, who she was pregnant with during the virus outbreak. She gave birth in April 2020. For Effie, the experience of pregnancy and delivery during the pandemic was traumatic, and she has spent time in therapy working through it. While her pregnancy elicited anger and grief, she has also begun to see that by overcoming the difficulties of a COVID-19 pregnancy, she is not only a good mother but also one who can handle anything.

Effie's story began in August 2019 when she first found out she was pregnant. Motherhood had been something Effie had always looked forward to. At one point during our interview, she told me "All I ever really wanted to be in my life was a mom." Despite being an anxious person, the early stages of pregnancy were a happy time for her: "My anxiety went away. There was never a moment where I thought something bad was going to happen, or that my baby was going to be sick or that I was going to have a miscarriage or anything like that. It was just intense calm." In March 2020, everything changed.

Like many Canadians, the pandemic's beginning was a difficult and unnerving time for Effie: "We were playing it by ear. It was really scary because nobody knew what was happening and everyone was alarmed at how sick people were getting, and then the World Health Organization (WHO) declared it a pandemic." During this time, Effie decided to cancel her baby shower, something she had looked forward to since she was a little girl. While there was sadness regarding the social aspect of the shower being lost, there were also the technical aspects that heavily affected Effie. As she was planning on having a large shower, she had

not bought everything she needed for the baby: "That made me panic more because all the stores were closed, and nobody was going anywhere. Everything was shut down. I don't have diapers. I don't have anything to baby this baby. I don't have receiving blankets. I had maybe one or two things I bought myself."

Effie had carefully planned her delivery, hiring a midwife and a doula to have a natural birth, but these plans were derailed after the outbreak of the virus: "It was constant stress, trying to figure out what the rules were, what I was allowed to do and who was going to be there." Leading up to her due date, Effie was unable to meet with her support system in person, her family or her doula, and her delivery ended up being a tumultuous process. It began with no warning after she felt dizzy with high blood pressure. Her midwife told her to come to the hospital right away. With no bag packed, she ran around her home in a panic trying to get everything she needed. She was admitted and diagnosed with pregnancy-induced hypertension requiring medication to begin labour immediately.

Since her midwife could not be in the hospital, the entirety of her care was transferred to a doctor she had never met before. Hospital staff had to set her up on an IV to keep her from having seizures and checked her blood pressure every hour. With a catheter put in, Effie was stuck in bed and was not allowed to eat. At one point, the nurses felt bad for her and began to sneak her food. She had to undergo membrane sweeps when the doctor checked her cervix multiple times, "It was the most excruciating pain I've ever felt." On top of this, she had a Foley balloon inserted, which she described as a balloon full of water that manually pushes down on your cervix to dilate you. After these painful procedures, Effie underwent an emergency Caesarian section.

As she wheeled herself to the operating room, Effie remembered bright lights and velcro straps. On the birthing process, she said: "I remember vaguely my daughter being born but very little of it. I remember they held her up, and I thought cool, and then I kind of lost consciousness." About waking up after the procedure, Effie said, "I remember waking up in the recovery room. I had no idea what time it was, and my husband wasn't there. I was by myself." Her daughter had breathing problems after birth and was in the neonatal intensive care unit (NICU). Effie could not meet her until later that night: "I was getting texts and Facetime from my husband, who was with her in the

NICU, and it broke my heart because I wanted this. I wanted my skin-to-skin time; I wanted to try and breastfeed her." Twelve hours later, she was finally able to meet her daughter. Following the birth, she noticed things began to change at the hospital: "The hospital was starting to change around this time. We went in not needing to wear masks or anything like that, and then you could start to hear nurses whispering in the halls. The vibe had shifted in the hospital." Effie's husband was told he was allowed to leave the hospital to get his clothes and come back. A policy change occurred after he left, and the hospital needed her room. They discharged her, and since she was no longer a hospital patient, her husband was barred from returning.

Her daughter was still a hospital patient, so Effie was allowed to stay. Due to the protocol changes, she could not leave her room or go down to the cafeteria to get anything to eat. The mask rule had changed, and she was required to wear one twenty-four hours a day, even when sleeping. These policies clouded her experience of early motherhood: "I couldn't smell my baby; I couldn't kiss her." At one point, she took off her mask to engage in skin-to-skin contact with her baby and the charge nurse told her that she would be forced to leave the hospital if she couldn't comply with the rules. Having reassigned all the lactation consultants, Effie had no access to breastfeeding support. The culmination of things was torturous: "There was one night I had an absolute panic attack. I could not stop crying. I wanted my mom. I wanted my husband, and I wanted to go home." Effie and her daughter stayed in the hospital for five days, alone.

After leaving the hospital, Effie and her daughter could not go out much. As she described it: "We stayed home for two years." There was no engagement in the quintessential "mommy and me" groups, no maternity photos and little contact with friends and family. The mental load of deciding what activities to partake in was taxing: "It felt like life and death like every decision I made was a life and death decision. If I go to the grocery store, am I going to die"? She felt frustrated by the government, noting that she believed the government would be there to take care of us if something happened. But now, Effie has trouble believing they will deliver in future crises.

While the pandemic experience was traumatizing, Effie recognized the amount of strength and resiliency it took to go through it: "There are always going to be scars there, but there is also strength and power that

comes from there as well." Like other mothers during this time, she looked to her daughter to get through the pandemic: "Having the realization that somebody relies on you, and not just in the way a friend or significant other would rely on you; it's that I need you to keep me alive. I don't care if you're having a bad day; you need to be there for me. Having that instinct to keep her safe and to keep her loved and happy, I really relied on her." Looking back on the experience, Effie had a large amount of pride, noting that she is a good mother and has full confidence in her abilities. At one point, she referenced the collective COVID-19 pregnancy experience as "feminism in action," stating "I think that everyone who went through this, we're just fucking tired of it, and we are badass. Badass moms who don't have time for anyone else's opinions."

Louise's Story

Louise is thirty-nine years old and works at a consulting firm in Alberta. She is married and has two children, a four-year-old son, and a baby she carried during the pandemic. Louise found out she was pregnant with her second child in November 2020 and gave birth in August 2021. For Louise, the pandemic compounded an already stressful situation in her life: trying to have a second baby while navigating the healthcare system with fertility challenges.

Louise and her husband tried to conceive naturally throughout the entirety of fall 2019, and shortly after this time, the COVID-19 pandemic began. They debated hitting pause on trying to have a baby as the virus created a lot of fear and uncertainty for their family. Louise expressed to me that while the pandemic was scary, she "felt more scared about the thought of taking a break from trying," so they decided to keep going. After trying for about six months naturally, Louise and her husband reached out to a fertility specialist. In the middle of COVID-19, this was a long process, and it took months even to get a referral. Daycares closed, and Louise and her husband worked from home. The switch to a home office was not a positive work experience for either. Louise told me: "I'm trying to stay calm so I don't get stressed out so I can get pregnant and yet I am the most stressed out I have ever been."

After months, Louise finally got an appointment to see a fertility specialist, but there was no option for in-person appointments. Like

other pregnant women during this time, Louise told me that accessing care was impersonal: "I found it a really hard experience to do all the fertility appointments virtually or by phone; it felt very impersonal and very lacking of face-to-face to talk about some really hard stuff." After a round of tests, nothing conclusive came back. The doctors told Louise and her husband that it was "unexplained secondary infertility."

Louise described this to me: "Basically you've had a kid; you're not getting pregnant again. We don't know why. There's no reason why you shouldn't, but you're not getting pregnant." Louise and her husband spent the summer handling the confines of the virus while trying to figure out the cost and process of pursuing other means to get pregnant. They decided to pursue a simple fertility treatment, but it was unsuccessful. Louise attributed this to the stress of everything going on in her life. In the background, her sister-in-law had just had her second baby, and her sister had become pregnant with her first. While this was welcome news to Louise, she had always envisioned having a second child alongside them: "It felt like those ideas were kind of slipping away as things took longer and longer."

After everything, Louise and her husband eventually became pregnant naturally. At her first ultrasound, the doctor informed her that the baby's neck folds were on the thick side, which could indicate a chromosomal abnormality. On top of this, balancing daycare closures and working was stressful, and Louise's office was not functioning well remotely. She worked from home during the initial stages of the pandemic from March through July. She was back in the office by November, but many people were sent back home to work again due to the next wave of infections. The logistics of moving back to a home office were overwhelming, and she could stay in the office instead of shifting back home once more. At that point, the stress of moving offices again was worth the increased risk of contracting the virus.

At her twelve-week ultrasound, her husband could not attend due to COVID restrictions. This was an exceptionally stressful appointment, as they were going in to find out more information about a potential chromosomal abnormality: "I think I had a panic attack looking back at the time just being so overwhelmed and wondering if we are going to get something back from this that is bad or worrying." Appointments with their genetic counsellor and midwife continued to happen remotely. It took sixteen weeks to find out that the baby did not have any abnormalities.

Louise decided to have a home birth, something she felt confident in as she had one with her first child. About two weeks before her due date, she remembers she or her son had a runny nose: "I was freaking out because like, if he gives it to my husband, and my husband can't come to the birth, I was worrying about what the delivery would look like and just keeping everyone safe and healthy." The delivery ended smoothly, but the baby had some breathing issues. With her first child, they ended up in the NICU for a week, and Louise was worried this would happen again. With the COVID-19 restrictions in place, Louise assumed she would have to be alone in the hospital with the new baby. Luckily, it ended up being a simple procedure, and they avoided an extended stay in the hospital.

Like other women I spoke to, Louise discussed the weight of decision fatigue and the stress of trying to gauge who to see and where to go in relation to risk. Throughout the pandemic, Louise felt that the government could have handled things better: "I felt they were often late to the game to put restrictions in and quick to open things up. As a pregnant person with a kid who can't be vaccinated, every time they would open stuff up, I felt less safe." Louise also felt communication from the government was confusing. At one point, she called 811 for help figuring out testing requirements, but this did not result in many answers: "I called 811, and she's like, 'It's okay you're confused. I am literally confused too, and I work here. I'm going to show you a flowchart, and you're going to see why you are still confused.'"

Despite the pandemic being such an overwhelming time, Louise looked back on some portions of it positively as it allowed her to spend more time with her family: "Everything dropped away, all the activities, all the planning, even playground didn't feel safe. So, we just walked. It was kind of awesome in a way." She also felt that the pandemic has opened a broader conversation around mental health and the resources needed to support it.

Joan's Story

Joan is thirty-three years old, holds a leadership position in municipal government, and is also pursuing further education. She is married with two children: a six-year-old and a two-year-old. Joan found out she was pregnant with her second child in August 2019 and gave birth in May

2020. For Joan, the traumatic delivery of her first child, mixed with the uncertainty of COVID-19 and hospital policy, heavily influenced her pregnancy planning.

To understand Joan's COVID-19 pregnancy, it is important to know about the birth of her first child. While her first pregnancy was relatively easy, her delivery was a traumatic experience. The pregnancy was overdue, and the doctors had to induce her. Joan has scoliosis in her back, and because of this, she was not a candidate for an epidural. When describing her labour experience, she stated: "So not only do you have induced labour, which is very intense because the hormones are through the roof, but not being able to have any pain management with that, other than morphine or laughing gas, which really doesn't touch an intense labour, was a really traumatic experience." Joan was fatigued from labouring, and the doctors had to use forceps during her delivery, which led to a third-degree vaginal tear. Looking back, Joan felt that because she was so confident going into labour, she didn't spend enough time preparing for how to access support during the birthing process. After the delivery of her first child, Joan had a difficult postpartum experience: "I deliver the baby. I bring him home. I'm completely injured from this birth. Hormones are plummeted; people are coming over. I'm overwhelmed. I didn't know how to speak for myself." She may have been experiencing postpartum anxiety or depression. It was not until recently Joan learned of a term to describe what she went through: birth trauma.

When she became pregnant with her second child, she did things differently and began the journey with a clear plan, which she described as a case-management approach. When COVID-19 hit, it changed all of her carefully laid plans. While her husband had been involved in coming to her appointments, he could no longer do so. The change in care was difficult to navigate because it became an even more sterile environment: "I went to an obstetrician, and they move fast on a good day. They're quite impersonal without a pandemic. Adding in those extra protective layers of being apart from people in the waiting room, being masked, having to spray everything down with sanitizer, it made an impersonal experience even less personal." Joan was able to access a psychologist to help her work through some of the anxiety she was experiencing while navigating a newfound loss of control due to pandemic policies.

Like many mothers during the pandemic, Joan found it stressful conducting added carework with her other responsibilities. Her four-year-old was home from school, and she had to balance full-time mothering with pregnancy and work. For the last month of her pregnancy, she developed a strong fear that she would contract the virus: "I had this very real fear that I would contract COVID-19, and I would be one of those stories on the news where the mom went in to have the baby and didn't come home. That was what I was seeing in the news. Maternal death was very risky during that time." Joan was also was afraid of the healthcare system collapsing when she needed it for delivery. Throughout the virus outbreak, the Alberta hospital system was constantly strained. Joan was concerned that they wouldn't have the resources to help her when she needed to access the hospital.

Joan told me she remembers the onus was on her to keep up with the changing hospital policies regarding her delivery and who was allowed to be with her. She would call the unit to ask what the delivery experience would look like, as not much information was given to her. She wished there had been a source of information, something like a hotline, where she could access updated information on hospital policies and protocols. She was often left to put things together with information from social media, which was stressful as it was not always accurate.

COVID-19 policies continued to impact her delivery experience. Joan sat alone in the emergency room through the intake process while her husband had to wait in the car until she was admitted: "You go from trying to have this community around you to it's just this eerie moment of quiet, where you just sit there, and you wait for someone to come get you, and your human who loves you can't be near you to help you go through that." At one point, as she was sitting alone, she thought to herself: "You know what, it's you at this point, like you have to own this yourself. You can't outsource your feelings to anyone else. I had to sit there not knowing if my husband was ever going to be able to come. I had to say, if I have to give birth by myself, how can I support myself through all this?" After about three hours of waiting in the car, Joan's husband could join her, and because she had such good plans in place, the delivery went smoothly.

COVID-19-related hospital policies shaped Joan's immediate post-partum experience. She described it by telling me: "You have the baby, and then you go back to your room. Then they lock you and your spouse

or your birthing partner, whoever that person was in the room. They don't let you leave until you are discharged from the hospital. You get on the ward, and then they give you your food, but when your partner or whoever it is has to go, they have to be escorted down to the cafeteria. It is a very controlled environment." She told me it was an interesting experience for her husband, as it felt like he was almost hospitalized with her in a controlled medicalized environment.

After they were discharged and went home, Joan found positive aspects that stemmed from the pandemic. For her, it made it easier to put boundaries in place regarding people visiting her: "I strongly believe that being able to say that actually helped my mental health postdelivery because I felt in control that I could see who I want, when I want and how I wanted. The onus was on me rather than feeling like I was literally this empty vessel that had birthed this kid for everyone else to love." Joan also felt that having her husband home was a welcome extra layer of support since he was not in the office due to the virus. Looking forward, Joan told me that she felt COVID-19 allowed for opportunity to look at how organizations do things and questions whether there are ways to improve. For example, Joan had to get a doctor's note to confirm she had given birth. To access it, she had to pick it up in-person as they wouldn't fax or email it. She had to bring her new baby with her, but he wasn't allowed in the clinic. Thinking about this experience, she told me: "It is stuff like that where I think, is there not a better way to support people who have just given birth?"

Stella's Story

Stella is a thirty-eight-year-old graduate student who works part-time outside of school. She is married with a five-year-old son. Her COVID-19 pregnancy journey began in October 2021 after the virus outbreak. Stella and her husband decided to have their second child after they felt the worst of the pandemic had passed in the fall of 2021. She got pregnant quickly, but soon after, the next wave of the pandemic began. Stella's story exemplifies that while there has been a societal push to "move on" from the pandemic, the virus is still affecting our lives, especially those who are most vulnerable. As described by Stella, "I'm pregnant in the postpandemic phase of the pandemic, right? So, it's real for me but not real for anyone else."

Stella's COVID-19 pregnancy experience was shaped in part by the birth of her first child, a traumatic delivery that required multiple forms of medical intervention. Stella had preeclampsia, was admitted for high blood pressure, and then had an induced pregnancy. She was in labour for forty hours and experienced convulsions and seizures throughout the labour. This experience led to planning for a Caesarian section with her second child and left her vulnerable to the virus due to her prior vascular health conditions. She was less likely to seek out support or ask for help; she did not want anyone in her house. Her family skipped holidays and social events, and she noted frustration with family members who refused to get the vaccine. Similar to the other women I spoke to, Stella said the hardest part was all "the decisions you have to make."

Throughout the early stages of her pregnancy Stella balanced the demands of mothering her son while balancing work and the risk of contracting the virus. Her son was periodically in and out of daycare while her husband was also working from home; his job offered little flexibility. Looking back on this time, she stated, "We couldn't continue, right? Like, we couldn't continue to do that. We learned in the earlier parts of the pandemic that it's completely unsustainable." Once her son was able to access the vaccine, he returned to daycare.

To access medical care, Stella tried to be the first appointment of the day when she first attended doctor's appointments to mitigate her risk. I asked Stella if she had been given any information from her doctor regarding pregnancy and COVID-19 and was surprised to hear that there was still not much information provided to pregnant women despite being years into the pandemic. Stella told me that she wishes there was more precise communication regarding hospital COVID policies. Of hospitals in her area, she said, "All the hospitals are on outbreak status, but what does that mean? Is the maternity ward on outbreak status? What is the maternity ward doing? What is the NICU doing? What are their protocols?"

Of the broader conversation surrounding COVID-19 and pregnancy Stella told me: "Women are not part of the discussion like they should be." She felt that it was easy to forget about pregnant women as people working from home and limiting their social contacts has decreased their visibility. Stella feels this can be applied on a broader level to the societal response to COVID-19: "When we surround ourselves with people who look like us and talk like us, we forget that other part of society exists.

Disabled people or marginalized people or homeless people, it's just easier to ignore those parts of society."

Stella feels that in some ways going through the pandemic as a mother was an experience that exemplified her strength as a mother, "We do it because we don't have a choice. I feel that's what parenting is about: you don't know how you're doing it but you just do it." Similar to Effie, she said that the pandemic has created a space for her in which she makes no apologies to others for her mothering practice, "I think that has been a positive outcome of the pandemic, it's just moms and primary caregivers being like, fuck this. You're going to see what happens in my life. We have no more care to give to other people's feelings about our lives."

As a researcher, it feels as though the pandemic has revealed the expectations of "the ideal mother" to be impossible, and for some, this has been a liberating experience.

Learning from the Women's Stories

While each of the women was impacted by the outbreak of COVID-19 in unique ways, several themes link each of their stories. Like most Canadians, the women initially felt uncertainty, fear, and confusion during the pandemic. They were trying to figure out what social activities were safe to engage in, which led to mass amounts of decision fatigue, exacerbating an already stressful time for pregnant women and new moms. Many felt the impact of social isolation, missing out on events they will never be able to revisit. Each of the women I spoke to felt the government and hospital system could have done a better job communicating the ever-changing restrictions and policies that impacted them during pregnancy. Who was allowed to be in the delivery room? What did the delivery process look like? How did the virus affect pregnant women differently? As there was little information being given to them and no supplemental resources, they took on the role of navigating public policy on health on their own. This mirrors much of the government's response to the COVID-19 pandemic, one of personal responsibility that often left the most vulnerable among us abandoned. At the time of writing this chapter, there is still no vaccine available in Canada for children under five and nearly all COVID-19 mitigation strategies have been lifted, including mask wearing in schools and daycare facilities.

While the pandemic was a difficult time for the women I interviewed, each of their stories serves as a remarkable example of maternal power. Despite the decreased support, lack of information, confusing healthcare protocols and increased risk from the virus the women manoeuvred their way through it all. They revealed themselves to be immensely strong in the face of adversity. As Effie stated, "We're badass moms." Despite their negative experiences, the women all expressed hope that we can learn from the pandemic to improve the lives of Canadians. Whether it be increased mental health services, added accessibility, or increased visibility, the women I spoke to felt that there are lessons to be learned from the pandemic that can better support pregnant women and all Canadians in the future.

Works Cited

Altman, Molly R., et al. "Where the System Failed: The COVID-19 Pandemic's Impact on Pregnancy and Birth Care." *Global Qualitative Nursing Research*, 8, 2021, https://www.ncbi.nlm.nih.gov/pmc/articles/PMC8020401/. Accessed 20 Feb. 2024.

Anderson, Emma, et al. "Maternal Vaccines during the COVID-19 Pandemic: A Qualitative Interview Study with UK Pregnant Women." *Midwifery*, 100, 2021, https://pubmed.ncbi.nlm.nih.gov/34198208/. Accessed 20 Feb. 2024.

Clandinin, Jean D., and F. Michael Connelly. *Narrative Inquiry: Experience and Story in Qualitative Research.* Jossey-Bass, 2000.

Fuller, Sylvia, and Yue Qian. "Covid-19 and the Gender Gap in Employment among Parents of Young Children in Canada." *Gender & Society*, vol. 35, no. 2, 2021, pp. 206-17. *Sage Journals*, https://doi.org/10.1177%2F08912432211001287. Accessed 20 Feb. 2024.

Government of Canada. "Economic Impacts and Recovery Related to the Pandemic." *Statistics Canada*, 20 Oct. 2022, https://www150.statcan.gc.ca/n1/en/pub/11-631-x/2020004/pdf/s5-eng.pdf?st=z-PxbY-mT. Accessed 20 Feb. 2024.

Kolker, Sabrina, et al. "Pregnant during the COVID-19 Pandemic: An Exploration of Patients' Lived Experiences." *BMC Pregnancy and Childbirth*, vol. 21, no. 1, 2021, pp. 1-13.

Ollivier, Rachel, et al. "Mental Health & Parental Concerns during COVID-19: The Experiences of New Mothers amidst Social Isolation." *Midwifery*, 94, 2021, https://pubmed.ncbi.nlm.nih.gov/33421662/. Accessed 20 Feb. 2024.

Rice, Kathleen, and Sarah Williams. "Women's postpartum experiences in Canada during the COVID-19 pandemic: a qualitative study." *Canadian Medical Association Open Access Journal* 9.2, 2021, E556-E562.

The Canadian Press. "A Timeline of COVID-19 in Canada." *National Post*, 24 Jan. 2021 https://nationalpost.com/pmn/news-pmn/canada-news-pmn/a-timeline-of-covid-19-in-canada. Accessed 20 Feb. 2024.

7.

words about birth

Wendy McGrath

fine lines on a peacock's feather
now a tracery of bone curving on screen
and beating heart
 wake and spread your fingers
 open your fist and let me
 look at what you hold

8.

The Creation of
the World

Lauren McLaughlin

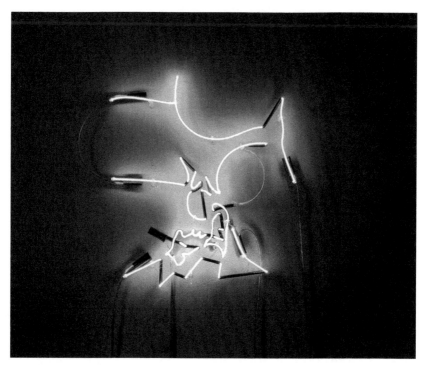

Medium: Neon, wire, and transformers, 2019, 60 x 60 cm

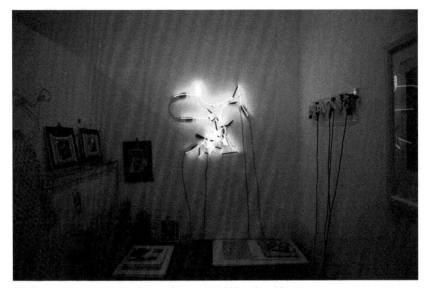

Medium: Neon, wire, and transformers, 2019, 60 x 60 cm

The Creation of the World is a wall-based neon artwork depicting a preg-
nant figure at the moment of crowning; the blue-gloved hands of the
midwife ready to support the emerging baby. The composition and the
artwork title refer Gustave Courbet's *L'Origine du monde (The Origin of
the World)* (1866) and Michelangelo's *The Creation of Adam* (1512).

The patriarchal and Western religious narratives surrounding the
female body, motherhood, and the creation of life that have dominated
art history, continue to impact the cultural representations of preg-
nancy and motherhood today. Having previously worked with neon to
explore my own experience of maternal identity through language, I
was interested in utilizing the unique properties of neon to explore
representations of the birthing body, with a view of creating an em-
powering representation of birth which challenged these limiting
representations.

Neon is historically associated with the advertisement of the female
nude as a sex object. By using the medium to illustrate images of birth,
the work aims to provoke a dialogue around the reasons why we are so
comfortable with the sexualized body but so shocked at the birthing
body. Drawing upon conceptual themes within the "Madonna-whore"
dichotomy and the depictions of the female body as either "sexual" or

"maternal," it aims to blur the boundaries between these two tropes and create a message of empowerment, strength and multifaceted maternal power.

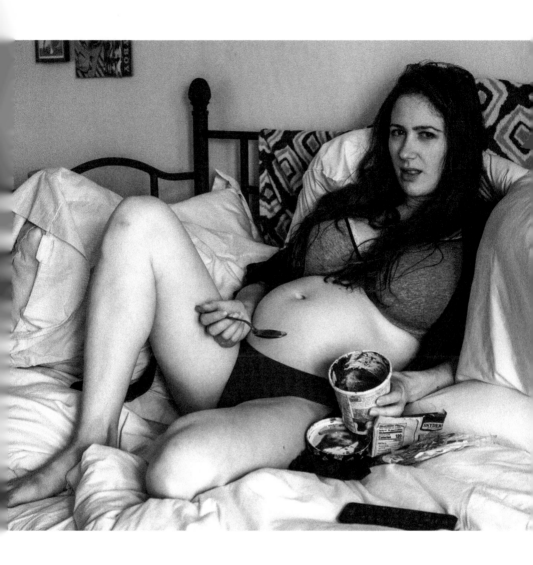

PART III.

MOTHERHOOD

9.

Mothering against the Grain: Preserving the Self by Losing It and Finding the Self by Preserving It

May Isaac

E ducated, high-achieving, well-read, and successful at thirty-two, I readied for motherhood with the meticulous organization, motivation, individual responsibility, determination, and ambition that had brought me success in life and my career. In preparation for conception, I abstained from alcohol. After meticulous research to determine the one best formulated to meet the special nutritional needs of women trying to conceive, I started a course of pre-pregnancy multivitamins. Once pregnant, I observed the rules of a healthy diet and exercise. I faithfully kept every obstetric appointment, marvelling each time at the developing being inside me, squirming on the ultrasound screen, so tiny yet so fully formed. At seven months pregnant, keen to communicate with my unborn baby, I assembled a fetal phone. By the time my baby arrived, the nursery was ready; I had researched baby names, attended birthing classes, and read a library of books on motherhood and parenting. My mother, visiting from India for the birth, was incredulous. "There are books ... books that tell you how to raise a baby?" she asked.

Thus began what would become a frequent theme of our mother-daughter interactions—her experience interrogating my education; her instinct challenging my reason; her community mothering chaffing against my highly individualistic standards; and her sense of Self, so

fulfilled, echoing inside my hollow Self, which screamed, "Is this all there is to it?" Raised in India and leaving home solo at eighteen to pursue education and a new and independent life in Australia, I found my perfect storm in motherhood. The profound, intense, and life-altering experience that is motherhood has been theorized and studied empirically in academic scholarship. It has, in turn, been eulogized, lauded, lamented, and parodied in popular culture, with "mother" being both a swear word and an instance of the sacred divine. Amid this loud and sometimes raucous chorus, voices speaking of how mothers seek and find their sense of Self are seldom heard. Motherhood is synonymous with sacrifice, devotion, and selflessness; it is an all-consuming identity in itself. Speaking of a search for a Self outside of it seems like sacrilege. Hence, there is silence. This chapter speaks into this void.

What then, is a sense of Self? The commonly understood and socially constructed meaning of Self is individuality. However, I move beyond this to conceive this expression of Self as fundamentally founded on actively creating a space where one is comfortable and at home with oneself. Crucially, it is found both in the knowing and doing—of finding and creating what is required to feel comfortable and at home with oneself. For mothers, when the socially accepted expression of our Selves becomes entwined with our children, creating a space to find and be our Selves is not only an intricate and complex process but remains all too often a forgotten one. To find our Selves, we must go "against the grain," meaning contrary to accepted or prescribed norms. I appropriate this term consciously because I have long been attracted to its rich tradition, especially in postcolonial studies of history and literature, of going against the grain of inherited knowledge or conventional wisdom to stimulate fresh, new, and insightful perspectives. In this spirit, I employ the metaphor as a reflective tool, one that is sharp, reflecting on my search for Self.

This chapter will unfold in two parts, as I wish to draw out two notions, both requiring a conscious going against the grain. First, I will explore the idea of preserving the Self by losing it and then flip this to tease out the notion of finding the Self by preserving it. For many women, the search for Self is expressed as a mother's quest or finding her Self through recuperating her maternal heritage and reconciling her childhood. The daughter's Self is found in understanding who she is by knowing whom and where she comes from. My mother has been an

extraordinary source of strength, comfort, wisdom, and, above all, a touchstone—lending form, character, and tension to my sense of Self. Drawing on my maternal heritage, garnered from childhood memories and joint reflections with my mother, I describe how, framed by her cultural context, my mother preserved her Self by losing it. In the second section, by going against the grain of my mothering practices, I lay bare the process by which, lately, I have tried to preserve my Self by finding it.

Preserving the Self by Losing It

The imbued memory of my childhood is steeped in community. Mine was a childhood lived in the collective. Sunday afternoons, for me, still evoke the scent of smouldering frankincense that surrounded our suburb, signalling the weekly surrender of the girls in the neighbourhood to hair massages and head scrubs from our mothers, who finished by conditioning our hair with the spicy vapours of frankincense. Journeys to school were never alone but noisy, pooled excursions with other children crammed into a rickshaw, a neighbour's car, or a public bus, each of us going to various local schools but travelling together. Discipline was freely doled out by "aunties" and "uncles"—not my relatives but community members. Tales of my misdeeds often arrived home well before me, incurring a double wrath—first for the indiscretion itself and then for the ignominy my parents endured for having been alerted to it by the reporting uncle or aunty.

Joys and sorrows were never private but experienced in the collective. In both small and grand moments, life was shared. A box of chocolates was always shared with neighbours. Wedding invitations routinely invited your "family and your friends" to the occasion. A relative visiting your family from interstate or overseas was contested over as everyone's guest. Grief, too, was experienced in the collective. Death was never hidden but exposed in all its starkness. The loss of a loved one was mourned, publicly, with the community gathering around the body, in the bereaved house, with children unshielded from the raw and often painful expressions of adult emotion.

My childhood memories of my mother also reside in the collective. She was always surrounded by other women. When I speak to my mother of this time, she recalls her network of friends—women in whom she found solace and friendship, whom she implicitly trusted to

discipline and nurture her children. She recalls, fondly, many occasions when she heard me cry and ran to help only to find me already being comforted in the arms of another woman. "It was just the way it was," she says when I ask how she created such a network. "I didn't have to do anything. Everybody just knew what to do. But I was not as busy as you," she says. Household tasks like shopping and cooking were often shared, but more importantly, domestic help was readily available and accessible to middle-class families such as mine. However, it came with the responsibility to enfold the domestic into the family and take life-long responsibility for it and for their family, which often involved educating them or their children and ensuring their comfortable old age. They, too, become part of your family and community.

My mother speaks affectionately of the village of neighbours, extended family, domestic help, church, and school that raised me. She is adamant that she found individual freedom as part of the collective. When I ask how that was possible, she says, "I didn't have to worry about what you were doing. I knew that everyone was looking after you, so I never felt I alone was responsible for you. So, I didn't have to be a mother all the time like you have to be." I, too, felt the strength of that community and the strong and intricate net it wove around me. However, for me, it was a net, which, much like one around a trampoline, gave me the freedom to bounce high and safely but always only in one place. I craved independence to get away from what I felt then were the stifling bonds of community. When I speak to my mother about this, she acknowledges, "Yes, you wanted to be independent, but I was happy to be interdependent." When I ask what interdependence meant to her, she says, "Well, we all knew we couldn't and didn't have to do everything by ourselves. We were happy to depend on each other. There was no shame in that, only lots of joy."

I translate my mother's experience as preserving her Self by losing it. She actively lost her individual Self in community mothering, finding, in return, the freedom to express her individuality, which she describes as "not being a mother all the time." Admittedly, the culture of community mothering around her helped. Yet her choice was still an act of trust, encompassing the willingness to surrender her individual identity and privacy as a mother. Ironically, community mothering, which I often found restrictive and omnipresent, I now credit for fostering an overwhelming sense of confidence, resilience, and security within me.

Going against the grain of my mothering practice, I remember the sharp pangs of isolation and loneliness that were my lot as a new mother. Like so many other women of my generation, I found motherhood to be the most gender-enforcing experience as a woman. What cut deepest, was how, despite having a loving and supportive partner, my own experience fell in line with research that finds that attitudes of men and women become more traditional after the birth of their first child. I acutely felt the weight of responsibility for the baby that lay individually with me. As a mother, I became the pulse of the family. Caring for the baby with no prior discussion, consultation or even consideration automatically became my responsibility. It was all up to me; I had to either provide care for the baby or organize and manage the provision of such care. To speak up against this model felt like a betrayal of mothering itself, which, after all, was the most important job in the world. I was expected to do all and to enjoy doing it all.

I longed for the ready and easy intimacy with fellow mothers that I witnessed my mother enjoy: the phone calls exchanging everyday chatter, the unannounced pop-ins leading to unending cups of tea, and an emotional load being lightened by sharing and laughter. I craved the impromptu get-togethers of my childhood, prompted simply by the need to share a special meal a mother had cooked with her friends. I understood now the joy and relief that spending time in the company of fellow women had brought my mother. I lamented the lack of mentoring and scaffolding available to new mothers like me. I felt exposed instead to a constant stream of self and peer evaluation of my mothering practices as I donned the mask of motherhood and tried desperately to be a so-called good mother.

I feel sharply the vivid contrast between my childhood and my children's. Theirs is the individual, self-centred life of the modern, albeit privileged, middle-class, Western child. They live largely unencumbered by a village that restricts and imposes rules of respect or expectations of behaviour on them. The heavy burden of discipline is solely the responsibility of their parents, mostly their mother's, and meted only in private. However, in what seems like the ultimate irony, while the restrictions of community parenting fostered my yearning for independence, I have found that while the theory and prescribed goal of modern mothering is to build resilience and independence in children, its practice does exactly the opposite. A good mother is measured by how much she does

for her children—volunteering at school, cheering on the sports field or driving her children to endless extracurricular activities. Indeed, the "mother" tag is a job description—tuck shop mom, soccer mom, working mom, dance mom, and so on. A good mother is judged on her effort at ticking these boxes and fulfilling these roles. It is a bad mother who relies on other people or the community for assistance. As I reflect on this phase of my mothering, I can only conclude that in contrast to my mother, who preserved her Self in community mothering, I lost my Self by preserving individual mothering.

Finding the Self by Preserving It

The process of finding my Self by preserving it began relatively recently. Like many educated, high-achieving women, determined to do mothering well, I took a large cut in ambition and salary, meaning that my much-loved career stuttered, stalled, and then died. My career was the baby I gave up on having my baby. I trod the well-worn "mommy track" and became part of the gushing pipeline of educated women who leave the full-time workforce at motherhood for caring commitments. Now, with older children, again, like so many other women, I am in the third phase of the mommy track—wanting to return to full-time work and to restart my career but finding that my motherhood break means that I have to effectively begin again.

Hence, I recently commenced study towards a PhD with my research topic, indicative not only of my own experience but also representative of a larger, curious conundrum. Why is it that at a time when more women than men are graduating worldwide, the gains of this education equality are not reflected in the workplace which is still unequally gendered? I have made some disheartening discoveries. In Australia, female graduates have outstripped males at record levels with almost 45,000 more women than men completing tertiary qualifications in 2014, a 20 per cent increase over ten years. Of all women aged twenty-five to twenty-nine, 39.6 per cent have achieved a bachelor's degree or above, compared to 30.4 per cent of men in the same age bracket. Women currently represent 59.5 per cent of all completed undergraduate and postgraduate higher degree courses.

Yet despite this educated female population in Australia, there persists a particularly gendered workforce. Women are overrepresented as

part-time workers in low-paid industries and in insecure work, congregating in female ghettos of clerical work, call centres, marketing, and human resources (HR). Meanwhile, they are underrepresented in leadership roles in both private and public sectors. For example, of all ASX All Ordinaries boards, only 19.4 per cent are women; of the CEOs in the ASX 200 companies, only ten are female. Women struggle to gain and keep top academic positions. A twenty-five-year-old woman in Australia, with a bachelor's degree, will over her lifetime, earn AUD 2.14 million, while her male equivalent will accumulate AUD 3.66 million—effectively a 1.5 million-dollar "gender tax" on women for taking time out for mothering. The average full-time weekly wage for a woman is 18.2 per cent less than a man's, meaning the average Australian woman works an extra sixty-six days a year to earn the same pay as the average man. It is no wonder then that women end up with two times less superannuation than men. All the while, Australia is losing over eight billion dollars each year for undergraduate and postgraduate women who do not enter the workforce.

Worldwide, the statistics are similar. In the United States (US), 43 per cent of highly educated women leave careers for children. In the United Kingdom (UK), female medical graduates outnumber males. However, fifteen years later, after career breaks for motherhood, they will work 25 per cent less than their male counterparts—a prospect likened to a time bomb threatening the structure of the UK national health system. As female education levels have increased worldwide, it has been estimated that raising female employment to male levels could have a direct impact on GDP increases of 5 per cent in the United States, 9 per cent in Japan, 12 per cent in the United Arab Emirates, and 34 per cent in Egypt.

Studying these statistics has given me much cause to go against the grain of my mothering practices and my work-life choices and place my Self under the searing spotlight of theoretical analysis. This has been a sometimes visceral experience. Convinced that, in sacrificing my career for children, I made the hard but right choice, I have found mounting evidence to the contrary. For example, a recently released Harvard study of fifty thousand adults in twenty-five countries found that working mothers are good for our children and daughters of working mothers are more likely to be employed in supervisory roles and earn higher incomes, while sons are more likely to spend more time on childcare and

housework. Several times in my research reading, I have had to take a deep breath and accept a hard truth or walk away from my desk for a breather to let something momentous sink in. I have discovered that my life aligns perfectly with what theory tells me. There is a name for the mothering I did unwittingly: intensive mothering, the gold standard of modern parenting that we are all judged by.

Intensive mothering is a gendered model that places the heavy lifting of child rearing overwhelmingly on mothers who undertake the majority of the physical rigours of childcare and associated domestic housework. It is based on the fundamental belief that women are inherently better at parenting than men. Although intensive mothering acknowledges that parenting is hard, it demands that mothers make the child's needs a priority. This form of parenting holds a persistent and persuasive sway over all mothers regardless of whether they are full-time mothers or if they stay in the workforce. Working mothers juggling the demands of intensive mothering are proven to do a "second shift" of childcaring and domestic work in addition to their paid work. Indeed, Australian mothers spend twice as many hours each week as fathers in caring for their children under fifteen. As a curious paradox, it is worth mentioning that even as female education levels increase worldwide, intensive mothering is paralleling this increase by spreading rapidly across the globe and intensifying even further.

Going against the grain of my mothering practice, I can now reflect on how much the ideology of intensive mothering had influenced me. I did not knowingly consent or sign up for it, but such is the power of ideology—in this case, mothering ideology or the dominant set of beliefs about what makes a good mother. Ideologies are like the cacophony of signs and sounds on a big city street; they are impossible to ignore, creep into your consciousness subliminally, and are reinforced daily. To seek Self satisfaction beyond motherhood requires a conscious articulation of that need, beginning by admitting that motherhood alone is not enough and by going against the grain of what prevailing ideology demands. This begins the process of finding the Self by preserving it, which for me has found expression in finding an outlet for the nonmother part of me, an acknowledgement of my career-and-education-loving Self.

Conclusion

In my quest for Self and uncovering what is required to make me feel comfortable and at home with myself, I made two main discoveries. First, in community mothering, there may be answers to the isolation and loneliness that plague new mothers. However, this requires a conscious willingness to lose the individual tag of mother, trust in the community and most importantly, a community and culture that make this both desirable and possible. Second, educated, high-achieving women who often come late to motherhood are the most fervent practitioners of intensive motherhood. Indeed, they are its torchbearers. It is these women, too, who are more likely to experience the guilt and anxiety of new motherhood as well as the pangs of regret that the loss of a career brings. In ruminating on my personal experience, I am, perhaps, relating the stories of many such women. May my voice add volume to the chorus and may it become a deafening roar as we break the silence on our search for Self.

10.

Still Wild: Towards Empowered Solo Mothering of Teens

Rebecca Jaremko Bromwich

O nce upon a time, when I was in my twenties, as a newly minted lawyer, settled down and married to a young doctor, I wanted to build a perfect life worthy of Pinterest and the new social media platforms just getting started. I was going to live not just a good life but a picture-perfect life. I had four kids in the space of four years. This was nearly two decades ago now, and that period is a blur. Sleep deprivation and a whirlwind of busyness will do a number on your ability to acquire and retain memories. I am glad I have pictures. They remind me of how much, amid motherwork being hard work, I loved the joyful, sun-dappled moments I had with my babies and young children. I loved singing to them, dancing with them, swimming with them, and carrying them. We had our own little culture, expressions, and world. Nothing about my experience of mothering was mediocre. The children were magical, and changing three sets of diapers a day was awful. Waking up sixteen times a night was routine. It was, in short, epic. I didn't mind. I was an over-achiever. I was trying to build a Norman Rockwell world of ambitious proportions, but what grew around me, the children themselves, was something more magnificent than I could have created. It was not a tamed, settled-down world under my control. Motherhood is something wild.

It might not be altogether surprising to hear, in the context of how I approached motherhood (by storming it), that I read only one parenting

book. It was called *What to Expect When You're Expecting.* On the whole, that book is not bad. I had, by and large, healthy pregnancies and, thankfully, healthy children. It could have been much harder, but that didn't make my early years as a mother easy. Nonetheless, I was richly blessed with a well-funded, stable period in parenting babies and young children.

Then, just as all four of my kids became teens together, I got divorced. My life is evidence of the adage that the perfect is the enemy of the good. The photo ops that grew more intensely and carefully curated over the years increasingly depicted an illusion, a performative narrative of familial bliss that was a lie. It is impossible to tell the whole truth because each detail unfolds into another, but it is clear that my perfect life, like my husband's fidelity, was a lie.

My carefully constructed Norman Rockwell home turned out to be a house of cards, and it toppled. This experience is statistically unexceptional. Almost 50 per cent of mothers will separate or divorce from the other parent of their children. A split from our co-parent could be reframed as simply something to expect when we are expecting, but it is never the plan. I won't relate the details of the split because they are sordid, boring, predictable, and irrelevant. The point here is I became a solo mom. I went from being a well-resourced, financially comfortable coparent in a socially lauded power couple to a solitary income earner amid family law litigation and acrimonious conflict, attempting to prevent scandal. I went from having a (somewhat apathetic and very busy) partner in parenting to having essentially an opponent, someone who sought to undermine my every attempt to mother my children effectively.

This changed, too. We managed the legal aspects. We settled them. I bought a house. I renovated it. I changed jobs and habits. We split the parenting time, so the kids were now, ironically, with their father much more than they had been when the family was intact.

Amid all this, the children grew. It made me deeply sad that I could not offer them a picture-perfect Norman Rockwell world. It also made me sad to stop being a winner on social media and to have that carefully curated social media identity implode. Yet the kids grew. They grew profane; they grew pubescent; and they grew beautiful and brilliant and strong and wise and angry and happy and sad. They did what children do: They grew into individual people. And it does not feel like I live in a broken home. I am the first woman in my family to own her own house.

I make my own money. I make my own decisions. I am in no rush to change any of that. Divorce feels now more like a luxury purchase than a tragedy. I have security, autonomy, and agency. I respect my children's father.

So, I am thinking of the person reading this who may be pregnant, who may be a new mother, and who may be young and determined and stubborn and shallow and insecure and arrogant and dealing with their traumatic childhood memories, like I was, or who might be older or younger and more nervous, and what I want to say to you is this: trust it. Trust yourself. Trust the journey. Trust the good feelings, the bad ones, and know that you cannot be, neither should you be perfect.

What should you expect when you are expecting? Moreover, what can I, who approached so much of my life with hubris and ambition I'd like not to replicate going forward, say to you of value? Expect to stay wild. You will have wild thoughts and feelings, and your life will be unruly. Expect the unexpected. Expect that your plans will not come to fruition as anticipated. Make them anyway. Expect that it will be hard. Expect to lose sleep. Expect your relationship with your partner, if you currently have one, to change. This will be hard, but you have separate and distinct relationships with your children from your relationship with your partner. Trust yourself and trust that process. You cannot do everything. You don't need to be anyone or anything other than who you are.

Motherhood is no happily ever after ending. There is no perfect home life, and the effort to create one is an anathema to fostering a good one. Motherhood is not an ending at all. Expect to be amazed. Wild and wonderful things are coming.

Journeys into Liberation: Rewriting the Maternal "I/My" in Poetry on Domestic Abuse

Guinevere Clark

Introduction

Motherhood and domestic abuse, considered in tandem, are traditionally loaded with negative connotations, such as restriction and disempowerment. However, both situations can present opportunities for empowering transition, akin to a journey. Through poetry and its analysis, I propose that the maternal subject can be rewritten to demonstrate strength and transformation in passages to freedom from abuse.

The ideas explored in this article lay the groundwork for a future body of creative praxis, pointing to much-needed ongoing social, feminist, and literary debates on the intersection of mothering and domestic abuse. Speaking on violence against women, Elizabeth Acevedo states that her "work cannot get away from it" (TEDx Talks). Acevedo discusses moving the conversation of abuse against women away from a "quick hashtag or a short by line," instead arguing that the "work of art is to elevate these stories." Poetry on abuse, Acevedo states, is ideally "antiquated and part of a bygone era." It would be best, she claims, that these poems had no use in society but concludes that for now, poetry on

abuse towards women that raises personal stories to the fore has an important and relevant function in cultural debate and creative writing presentations.

"Survivor speech," according to Linda Martin Alcoff and Laura Gray-Rosendale, "has great transgressive potential to disrupt the maintenance and reproduction of dominant discourses as well as to curtail their sphere of influence" (206). By speaking out, mothers can expose traditional narratives around gender expectations that have kept experiences within unjust or violent relationships hidden. By refiguring stories of maternal domestic abuse as phases of discovery, individual progress, or evolution, the focus shifts from ideas and practices that support and play into fixed patriarchal entrapment and instead inspire narratives of liberation.

Using poems based on my experiences within domestic abuse scenarios, written reflectively, this article illustrates my theoretical interest in liminality—otherwise known as "the in-between of a *passage*" (Thomassen 2). I share ideas on the liminal space of the abuse dynamic and writings upon it, where binaries of good/bad, private/public, and comfort/discomfort begin to blur or cross over, forming critical interplays in a text. My poems highlight that before the release into a more liberated life, mothers can exist in liminal space—within an "epistemic tussle" between dichotomies (Mukherji xx). This betwixt experience is shown in abusive situations, where mothers may be between homes, relational roles, or firm identities and may especially experience disharmonies and disruption around love, romance, family, and living space.

This article also draws on the work of Sharon Hayes, who has developed ideas on "key discourses used by women to make sense of their abuse and assist them in disengaging from their partners" (6). The discourses that Hayes highlights about abusive scenarios are focused on the tripartite influence of patriarchy, psychology and "romantic love" (56). I do not assume to speak for all mothers who have lived through abuse. However, I do have the "privilege" of being able to speak from my experiential voice (Munro 24). Epistemology has gathered value and impact through the third and fourth waves of feminism and offers direct routes into women's lives to facilitate personal awareness, empathy, and social change.

For this article, maternal domestic abuse is the focus rather than any other abuse scenario. Andrea O'Reilly states that "mothers need a

feminism of their own" (13), and in that vein, I suggest that a domestic abuse situation can be different and hold unique elements for a woman who is also a mother. Worryingly, statistics point to maternity increasing the prevalence of domestic violence, with some research suggesting that "1 in 6 pregnant women suffer domestic violence in the UK" (Bates 246). Despite many exposed patriarchal injustices against women— through movements and campaigns such as #metoo, Everyday Sexism, and The Double X Economy—there is still a dearth of accessible female-authored poetry and creative texts on the theme of maternal domestic abuse.

Poetry on maternal domestic abuse often shares the child's as well as the mother's presence and fits within a three-way structure of mother-child-antagonist. Within this structure, there can be various crossovers of perspective or emphases according to the unique situation written. The perpetrator-antagonist in my poetry is male. I acknowledge that abuse also occurs within same-sex and transgender relationships and can be inflicted by women onto men. The maternal subject in my poetic analysis is termed a survivor-narrator rather than a victim, thus redefining defeatist cultural scripts around abuse.

This article offers a basic roadmap for the poetics and analysis of works around maternal domestic abuse. I suggest the following six textual considerations to help elevate the impact of creative writing on this theme, which I have titled "The Six Steps to Embracing the Poetics of Maternal Domestic Abuse":

1. Study and use the power of start and end lines or opening and closing stanzas.

2. Expose the "lesser beats" (Heal 124) in texts and express the subliminal or what is not overtly seen or said.

3. Present one's truth as a mother.

4. With tact and if fitting, include the child in the text.

5. Use a predominantly first-person approach.

6. Identify the passage, journey, or potential opening into liberation.

This six-step approach aids the development of creative writing as a form of therapeutic intervention, assisting mothers to reimagine or cathartically reveal phenomena from their lives. Poetry crafted upon raw experience enables mothers to distance themselves from actual abusive

scenarios and discover perspectives that were not necessarily available at the time of the abuse. Although engaging with trauma from memory can be "fraught with danger," (Martin Alcoff and Gray-Rosedale 213) in supportive, trauma-informed settings and peer groups, the benefits can outweigh the risks and begin to unravel cultural power narratives often at play in women's lives. I propose that rewriting complex or harmful domestic experiences unlocks voice, allows mothers to enter new communities, and encourages expression around undesirable human interactions that may otherwise propagate in hidden or private spaces.

Beyond the broad remit of the confessional genre, I do not advocate a formal poetry style in creative texts on maternal domestic abuse. However, there are considerations around grammar, form, and prosody that may be useful in basic but powerful ways. The full stop or stanza, for example, can be considered more deeply as a simple boundary marker, pointing to the end or containment of a behavioural pattern or experience. Metaphors, symbols, and archetypes are helpful ways to find both personal distance and affinity in the writing process, offering multifaceted aesthetics. The recurrence of abuse as a pattern—emotionally, psychologically, or physically—may be utilized as a synectic angle in the form of a refrain, with repeated words or phrases in the poem. Creativity around poetic forms—such as the epistle or letter poem, prose, or haiku poem—can instigate a route into expression, with either freedom or restriction around language, to suit the subject's writing goal or personal experience.

There may be recurring tropes identifiable in poems on maternal domestic abuse, such as refusal of closure, definitive endings, brave or joyous new beginnings, and blurry or conflicted scenes and relationships. Recognizing common traits in the poetry written by mothers who have experienced abuse within their homes leads to an evolving weave of thematic psycho-social, matri-feminist, and creative literary research.

Confessional Poetry

> The world is blood-hot and personal
> —Sylvia Plath 71

Confessional poetry evolved from the more objective stance of the modernist poets, becoming prominent in the late 1950s with Sylvia Plath, Ann Sexton, and more recently Sharon Olds. Associated with the rise

of psychoanalysis, confessional poetry as a highly subjective style differs from automatic and stream-of-consciousness work in that it is a more "skillfully worked up expression of personal feeling" (Strachan and Terry 178). There may be an element of shock to confessional work, as in its starkest form, it deals with aspects of the traditionally forbidden or private worlds.

The recent renaming of the confessional style includes "personal," "autobiographical," and "self-exploratory poetry"—countering the term "confession" and its association with religious sin, criminality, or a psychological breakdown of some form (Gregory 35). "Autoethnography" is another term used for texts which reflect deeply on personal experiences and considers wider social context. Sidone Smith and Julia Watson describe "backyard ethnography," which focuses on the everyday utilization of autobiographical material, beyond the gloss of commercialism and published writings (17). Rob Pope points to a more egalitarian angle on the creativity of linguistics and the notion of a "grounded aesthetic" (12). Whichever term is used, the essence of confessionals as an exposure towards the truth of one's life is seen flourishing in contemporary blogs, forums, social media, diaries, and memoir publications.

Confessional writing is typically authentic, sincere, and associated with the real life of the author. It is usually set in the first person, refers to names and scenarios known to the poet, and is rooted in work that has prohibition around "expression by social convention: mental illness, intra-familial conflicts and resentments, childhood traumas, sexual transgressions, and intimate feelings about one's body" (Gregory 34-35). Elizabeth Gregory continues: "While ostensibly the site in which firm identity (the 'truth' about oneself) is asserted, confession turns out to be a place in which received definitions of gender, family role, the mind/body relation, and poetry are submitted to scrutiny and become blurred" (38). The blurring of "received definitions" that Gregory discusses, relates to the interplay or conflict of subjects and experiences, surmountable to new identities and transformation. Acknowledging maternal domestic abuse as a journey through which women may pass, and which often correlates to episodes of confusion or ambivalence, mothers who capture abuse poetically from varying stages on this journey reveal a unique aesthetic. This new aesthetic, I suggest, deals with liminality from fixity and empowerment from disempowerment.

Maternal domestic abuse experiences bring multiple dialogic and relational qualities and are well situated in a framework that considers blurred, in-between, or liminal space. Confessional writing may create a picture of uncertainty or initiate a clash with received, traditional binary narratives, such as good/bad, forbidden/allowed, male/female, or real/imagined. However, I argue that it is important to step into the terrain of the in-between, not just for individuals who have experienced abuse but as a feminist stance—to tackle and reveal repression and elevate the voices of survivor-narrators. The poetics of abuse expose shifts and tussles within inner and outer truths on journeys of emotion and action within mothers' lives. In reading confessional work, the power and exhilaration may simply come from a connection with selves that we recognize as similar (Gregory 36). Sharing and acknowledging maternal domestic abuse through creative confessional texts is paramount in adding to pathways of liberation.

I will now analyze three of my poems, taken from a 2023 body of PhD work, entitled *The Egg in The Triangle*. These poems were in part inspired and supported by my participation in a creative writing group run through my local Women's Aid. The group's teacher had lived through abuse herself and had an interest in liberating service users through the creative writing process.

My Moon

breaks through the door,
 asking
for love, with that
man-on-the-moon look.

He teases in circles,
 infuses my dreams, diamonds
 the light, looks beautiful, laughing
staggering in—blue.

So, I fed him,
 licked him,
did what he asked;
convinced myself I was white enough,

wise enough, for this moon,
 that we could last.
Then I'd catch him—full
pumped, pouting at the
 other side of the planet,
 each dusk,

stirring the sea and women new to him.
I'd protest, wave at the side of his head,
 speak to him gently, too sensibly,
 squeeze the lies

from his too cool
 heart,
 pipe
 tubes of
 poetry
 into
 the
 night's
 arc.

It made no difference.
 He kept drifting with the winds,
 puckered face, greedy
 for the glint of the cosmos.

 When I finally found him—
a chipped opal, curving
down my path,
 lips long kissed,

I could not have him back,
 could not
 soothe that sun-spotted
 temple,
reason with his smoky mind,
place his white plate, by our son.

In the first line of "My Moon," a red flag is raised regarding the dynamic between the maternal "I" and the antagonist, as the barrier to the mother's home is broken into. The poem proceeds to present a romantic wrangle between the "beautiful" man of dreams, who transgresses boundaries, "asking / for love, with that / man-on-the-moon look." That the antagonist "teases" is also a clear indicator that the poem is dealing with a trickster figure, who humiliates others, but still, the maternal subject feeds him, licks him, and "did what he asked," overly nurturing the male. The maternal "I" is presented with a self-conviction that she "was white enough, / wise enough, for this moon," and that the relationship would "last." This emphasis on maintaining an abusive relationship as an endurance, desperately hoping for change, is akin to Hayes's ideas on "the tenacious and insidious hold of the romantic love narratives for victims of abuse" (57).

"My Moon" starts with the complexity of abuse without any lead-in to the morally ambiguous situation. Compassion and care tussle with lies and physical dominance. The poem exposes issues of boundary transgression and spatial vulnerabilities that often exist in abusive relationships, especially if fathers use contact times to perpetuate disrespect for the mother. In the poem, the mother's individual experience reflects a "broader gender hierarchy" and social expectation around men maintaining a dominant position and women a nurturing position (Hayes 57). Changed locks, returned keys, bolted doors, or legal agreements regarding contact with children, or in harsher cases, restraining orders can establish methods of protection on maternal space. However, without clear and maintainable boundaries, the threat of the antagonist can linger as discomfort or anxiety, even in his absence.

Leaky or weak boundaries are typically liminal or blurred. The poem demonstrates a porous home and clashes with safety/danger, among other dichotomies. Recognizing the in-between spaces occurring for women if they are not separated from the antagonist reveals internal and external conflicts. If the maternal "I" is still wrapped in the romantic narrative as an "insidious hold," or if the perpetrator-antagonist is the child's father, this can default to repeated exposure to abusive patterns and scenarios. All factors—weak boundaries, paternal involvement, and a bypassing of discomfort in the name of love or romance—can challenge the maternal "I" in her quest for liberation.

Throughout the stanzas of "My Moon," a list is formed of all the

disruption that the moon-man brings, from lies to infidelity, and igno-rance to uncommitted fathering. The lunar cycles of the antagonist are paralleled to the cycles of abuse, which similarly rise and wane, but rarely disappear for long. The moon could be seen as "queered" in this poem—demythologized as a harmless deity or nursery rhyme character (Heal 121). Instead, the moon is shown with a new persona, dissonant to benevolence and childcare.

Alongside mythic notions of the moon and anthropomorphized masculinity as the man-in-the-moon, the feminine quality of the lunar connects to an embodiment of fertility cycles. Within this dichotomy, which is evident in the poem, a blurring occurs in the text between male/female. There is a jostle of mythic and symbolic representation, among stability/instability and the tangible/elusive. "My Moon" shows textual liminality—in-between exact or traditional representation of its main metaphorical vehicle.

The maternal "I" has gendered the moon male. There is a dogmatic cycle of repetitive return and a power-over approach, seen through the moon man, akin to stalking or harassment— the antagonist in the poem keeps returning. His persistent push and pull energy challenges the maternal subject. In the all-consuming presence of the moon man, the mother is subjugated to either appeasing him domestically or sexually. Even in his absence, the mother still senses the ripples of his existence— in the sea that stirs as he pouts "from the other side of the planet." Those who have experienced domestic abuse may recognize the pervasive infiltration of the perpetrator as preemptive angst or rumination, re-garding their next planned or unplanned visit.

In the narrated journeys within "My Moon," the male moves within the public as well as the private world, whereas the mother is predomi-nately in the inner space of domesticity—a familiar trope. However, this is not to undermine that there is an internal and external journey for the maternal "I" in the poem. Having tried different ways to negotiate her existence alongside the perpetrator through submission, acceptance, appeasing, and entertaining in the home, eventually she simply "could not have him back, / could not." The mother reaches a place of liberation, manifested externally as she refuses to put out the male's plate. The shape of the family was porous and fractured, dominated by the irreg-ular moon-man. The mother evolves to determine and set a boundary upon the family unit at the symbolic family table—a place where all

manner of sexisms frequently get laid out. The end of "My Moon" is significant in that the initial nurture played out by the maternal subject as she, "did what he asked," reverts to noncompliance with domestic normalcy—not placing "his white plate" by their son.

The final lines in poems are important. They serve to summarize, offer potent specifics, or form new horizons and reflections on the poem's context—often to initiate a re-read of the entire text. That the son has no mention until the end-line in the poem is noteworthy. The son's omission in most of the poem suggests a need for, and gives space for, the mother's narrative to surface. The child's late inclusion in the poem also indicates how children can be additionally silenced—albeit in different ways to the mother—in domestic abuse scenarios.

"My Moon" demonstrates that even the magnetic, seemingly unchangeable, powerful energy of the perpetrator can be challenged. Throughout the poem, the mother shifts into greater safety in the household, with the prospect of less destruction and chaos. "My Moon" highlights that profound decision-making, which impacts the quality of maternal life, happens in the everyday places of the domestic—at the kitchen table, front door, or garden path—as mothers protect and liberate their cherished spaces, step by step.

Harbour

Adrenalin rich,
in the surge of the run,
I watched you – all night,
sleeping in my car. Face –
streetlamp orange,
till dawn.

Summer mist moors,
we walk hand in hand
to the toilet block,
as kiosk shutters unroll,
to a faint sun.

The old cisterns echoed.
Your skin – cold like an ocean

animal, buttocks pink
as I peel off your nappy.
My smile jars.

Into a wild breakfast,
on the shore, two tiny
plastic boats to grip and race
down the loud gullies
of the storm.

Nestled by twin cliffs,
in the musical shallows,
we laugh, on the run.
A new clan.

In that harbour,
I showed you when to stop
the frantic journey
of the boats with your hands,
how to sense loss,

angle into the sky's heat,
shape stories from shells,
find the best seat in a rock.

Cheeks set in a briny mask,
you know how to watch
tide's tip now, can hang
by my scavenged flames,
stare at a billowing twilight,
eyes patterned with stars.

From the blackening sand,
we carry the harbour's lessons,
in a loaded bucket,
back to the carpark,
for that slow drive home.

Shells chiming in my pocket –
like a new key, forged
from storm
and all that made me run.

"Harbour" opens with the physiological stress of abuse, involving the flight/fight response, which is often felt when one is faced with danger (Van Der Kolk 46). For the maternal "I" in this poem, adrenalin is "rich," indicating both a potent bodily reaction to a threat and a rich experience, comparable to a valuable moment or phase of revelation. The door of opportunity opened in the flight/fight response can be small but powerful, leading a mother into new terrains in accelerated ways, as she becomes an agent of her rescue.

Finding the abuse in "Harbour" is through attention "to the lesser beats"—what is said in the gaps of a text's narrative or is subtly inferred (Heal 124). When analyzing poetry, and especially confessional style poems, it is useful to know the context of the first-person, perhaps through backstory, a testimony, or from other creative texts that further explicate the scenarios presented. In the case of this article, I have stated my aim to explore personal rewritings of domestic abuse, so the wider epistemic context is determined. But what can be found if one attends to the "lesser beats" in this poem, coming to it with little or no author subjectivity or autobiographical background? In her matricritical framework, Olivia Heal describes how listening to and composing works of criticism that attend to "aspects of life that are ignored, misheard or deleted in forms of remembering" (124) are important in maternal writing (124).

Omissions in creative texts, illuminated through a matricritical reading, bring subversive, unspoken, or in some cases shameful aspects to the surface. In my experience, maternal domestic abuse brought feelings of shame, guilt, and disempowerment, alongside a deep moral struggle. There were many grey areas, spaces of dissonance and disbelief. Fear and doubt, both of which are seen by Bjorn Thomassen as "archetypal liminal experiences" (16) often prevailed as daily emotions. Ending up in a carpark with my young son for the night, as in the poem "Harbour," was devastating to me. I felt like a bad mother. However, having fled a family holiday and a situation of emotional, verbal, and physical violence, I knew on another level that I was being a good mother. The experience held ambivalence. Nonetheless, escaping trauma

in this instance held the seeds of liberation, which I was able to build on in my poetry and my life.

I could have rewritten the pain of witnessing discord and domestic unrest, potentially therein retraumatizing myself. However, this was not what I chose to elevate through my creative reassessment. Instead, "Harbour" works reflexively to explore abuse from the angle of the flight rather than the fight. The poem shows a textual way of disassociating from the original trauma to produce a "counter-memory" (Smith and Watson 14), wherein a reframing of the past occurs, thus aligning into the present in new ways. Working from the strong binary of the fight/ flight response gives multiple avenues into creative texts that choose to explore liberation over conflict.

I argue that the journey away from abuse into liberation cannot be encapsulated neatly into one poem, mainly because abusive relationships function on so many micro and macro levels, with numerous points of drama, location, contradiction, and tension. These types of relationships can also exist for many years, with disharmony lurking in the conscious and unconscious worlds of the mother. To allow the breadth of issues within domestic abuse to be expressed fully, it is useful to write and read about them from a range of perspectives and times. "Harbour" resembles the phase of "calm after the storm," which can be a powerful and welcome place to be for anyone who has lived through threat. The poem shows the mother's relocation from an abusive scenario—as part of a journey on a cycle of abuse—within the multi-levelled stages of transformation and emancipation.

The maternal "I" is "on the run" in a "new clan," representing a commitment to a new family dynamic—the perpetrator is not evident in this poem. The mother is empowered through living in the in-between, transitory spaces of the carpark and the beach, which both depict liminality— on the edge of one place and another. Her quest for liberation is amplified by the temporal aspects of dawn and dusk as she moves from "a billowing twilight" and "the blackening sand, [to] carry the harbour's lessons," making a passage into greater knowledge between light/dark.

Listening to the "lesser beats" in "Harbour" and other survivor-narrator texts, invites consideration of the journey from abuse into a space of refuge, where distance from the antagonist is created. This poem shows the freedom discovered in the natural flight response, and the

opportunity thus afforded to the mother for reflection at a symbolic and wild harbour. Maternal acts towards transformation and new thinking are empowered in this poem—by spatial and temporal liminality. The text demonstrates how mothers in abusive settings can find alternative, albeit unusual or untraditional spaces, and thus relocate into safer mothering practices.

An alchemical process is depicted on the beach in "Harbour," as the shells from the mother-child play pertain to "a key." In fairy tales and myth, the key is a sign of not just "key questions" that a character needs to ask but also of the entry into mystery or knowledge, typically after a dark or epiphanous revelation (Pinkola Estes 55). Through the flight response and the urge and commitment to find a better place with her child, the mother symbolically manifests the key to it and navigates into her future—equipped for change.

Shiver

Home of secrets, splattered
with shock-vomit. Always
the litter of a lie. Flowers
fade here – ground rifted
to falter.

But the good-bride plan –
mother of all is firing up
tea, always smiling
into the parch, in sickness
and in health.

Lips blistered,
muscles revved,
she steers her animus,
antler tipped,
from his entrapment.
Dawn is so liberating.

It's the wool of other women
that keeps her

on the back of it, how they end
her stories, wrap children
with a shiver into their chests.

Tracking wood's map,
she washes from springs,
eats petals
glossed with summer.
Earth to hem again.
She holds yin, a rising.

A voice from her pelvis. Rain –
diamonds
 each
 hair and finger.

"Shiver" uses a third-person voice, although the poem originates
from first-person experience and a dream state. Accommodating the
third-person in poetry allows the survivor-narrator to distance them-
selves from the original trauma, and offers another way to access per-
sonal stories that may otherwise remain unshared. Third-person texts
suggest a witness or intimate narrator over a first-person confessor.

The poem opens with the "home of secrets"—suggesting the hidden
element of domestic abuse. Claudia Mills sees secrecy as "corrosive and
damaging" and states that it is usually linked to unnecessary shame
(108). Secrets can be a "crushing weight imposed on family members, so
that the speaking of truth, even the public proclamation of the truth, can
be experienced as an act of liberation" (Mills 108). Emancipation and
scenes of freedom in this poem are explored; however, the first stanza
contains language about a secretive, domestic domain. The images of the
opening lines—"splattered /...shock vomit," littered lies, fading flowers,
and "ground rifted / to falter"—all associate with entrapment, illness,
waning energy, and unsteadiness. There is an air of desperation; home
is not pleasant or safe in this poem. In the second stanza, the mother is
seen to comply with or endure the destitute scene—"firing up/ tea, al-
ways smiling / into the parch, in sickness / and in health." Traditional
marriage or monogamous, committed partnering is implied through the
"good-bride plan" and as "the mother of all"—depicted in domestic
service.

In the third stanza of "Shiver," there is a turn-around, more formally known in the poetic sonnet form as a "volta" (Strachan and Terry 225). Although this poem does not align with the formal sonnet, it takes the poetic device of the volta to express a rapid shift of action and perspective for the mother, as she is shown to release herself from domestic confinement. This change in the narration within the poem also illustrates the interplay of binary or oppositional forces, often consistent with liminality, ambivalent states and transformational experience. The word "revved" in relation to the mother's muscles suggests a strength as opposed to the weakness demonstrated in the first two stanzas. Steering herself into strength rather than taking her allotted place at the cooker, the mother metamorphosizes her activity. This shift in the poem is accompanied by the powerful image of the animus as "antler tipped." The deer antlers in "Shiver" express an effective and mighty force that the mother recaptures to establish the change in her life, within her subjective volta.

"Shiver" displays the collective feminine giving communal support, shown in the lines "it's the wool of other women / that keeps her on the back of it." A sense of female sisterhood evolves as the mother is among kin, with other mothers seeming to know or predict her story. By the final stanza, the maternal subject is immersed in the nourishing, external world of nature as opposed to the internal, dry, and dangerous spaces of the earlier domestic scenes. According to Pinkola Estes, the dryness of a woman can be equated to a loss of self or a "sealing off of the creative and the wild" (305). Instead, the poem concludes with the mother washing from springs; she is "glossed with summer" to suggest a regeneration in symbiosis with the natural world and her wild self.

The final image shows the mother holding the female principle of "yin" and the voice of her body, which stems from her pelvis. She is sexually awakened, as "rain – / diamonds" her, cleansing her of the corrupt marriage and offering a new valuable connection to self. The poem depicts a mother interconnected with her deep creative self, epiphanous among water. Symbolic of "feminine largess," water "arouses, excites, makes passionate," expressing "the place where life itself is thought to have originated" (Pinkola Estes 304). "Shiver" sees the mother journeying to source energy for rejuvenation and sustenance in the "woods map." Referring to the maternal passage into liberation through a "map" also suggests that the path to wellbeing and transformation from abuse is an available route for others to follow.

Conclusion

Proactive approaches that convert maternal experience into material constructs, such as creative writing, align with the personal and socio-political aims of matricentric feminism. As strong internal and external forces are confronted, from domestic abuse mothers have access to a creative and transformative energy on the journey of the self. When embraced in poetry, maternal pathways from abuse, reveal how liminal space and transitory experience expose injustice and instigate change. New behaviours, expectations, identity, support systems, and locations are available to mothers, especially when the idea of a journey—however long, short or winding—is used to interpret domestic abuse. The journey concept, practically and cognitively, negates ideas of fixity within a difficult situation, providing the idea of movement through abuse rather than women feeling trapped or stuck in an experience happening to them.

The production of creative writing, in the chaos or pain of an abusive situation, does not necessarily equate to an automatic, instinctual response for mothers. However, using poetry in windows of support or calm away from hostile environments or with hindsight can enable survivor-narrators to reframe experiences. The dual response to creative writing on maternal domestic abuse—crafting and discussing it—is valuable in the following ways:

- To raise awareness around the patterns of and the effects of abuse.

- To understand the specific challenges that mothers may face in domestic abuse situations.

- To help form and build supportive grassroots and academic communities that tackle domestic abuse.

- To enjoy the cathartic benefits of self-expression and the confessional-style on themes and experiences of abuse.

I have offered "The Six Steps to Embracing the Poetics of Maternal Domestic Abuse" to raise the impact of these works, which can be applied in formal or informal writing sessions and incorporated as part of exploring a journey into liberation in single workshops or courses. Mothers' creative texts on abuse can be supported in specialist writing

groups, online forums, dedicated modules, via anonymous avenues that share works, anthology publications, and spoken word events to reach wider audiences. Processes of rewriting lived encounters can bolster the therapeutic effects within domestic abuse services. As unacceptable norms around gender politics, including destructive and perpetuating romance narratives and behaviours are exposed to multiorganizational bodies, a wider social picture and cognizance forms. Illuminating abuse honestly allows taboos around the subject to dissolve and mothers to become free from unnecessary shame.

This chapter offers ways for mothers to consider forming or accessing texts from the survivor-narrator perspective, and perhaps begin their poems, stories or critical analysis. Creative writing and confessional-style prose on maternal domestic abuse gives precious resources for further research and poetic inquiry. Mothers who speak out in their reframing of abuse forge brave and necessary steps towards interdisciplinary debate, impacting a vital and evolving direction in feminist literary aesthetics in the early twenty-first century.

Works Cited

Acevedo, Elizabeth. "I Use My Poetry to Confront the Violence Against Women." *YouTube*, 8 Apr. 8, 2016. www.youtube.com/watch?v=S-J0GliCLzCA. Accessed 22 Feb. 2024.

Bates, Laura. *Everyday Sexism*. Simon & Schuster, 2014.

Clark, Guinevere. *The Egg in the Triangle: Poetics of Motherhood, Sexuality and Place*. 2023. Swansea University, PhD dissertation.

Gregory, Elizabeth. "Confessing the Body: Plath, Sexton, Berryman, Lowell, Ginsberg and the Gendered Poetics of the 'Real.'" *Modern Confessional Writing: New Critical Essays*, edited by Jo Gill, Routledge, 2005, pp. 33-49.

Hayes, Sharon. *Sex, Love and Abuse*. Palgrave Macmillan, 2014.

Heal, Olivia. "Towards a Matricentric Poetics." *Journal of the Motherhood Initiative*, vol. 10, no. 1 and 2, 2019, pp. 117-29.

Martin Alcoff, Linda, and Laura Gray-Rosendale. "Survivor Discourse: Transgression or Recuperation?" *Getting a Life: Everyday Uses of Autobiography*, edited by Sidone Smith and Julia Watson, University of Minnesota Press, 1996, pp. 198-225.

Mills, Claudia. "Friendship, Fiction, and Memoir: Trust and Betrayal in Writing from One's Own Life." *The Ethics of Life Writing,* edited by Paul John Eakin, Cornell University Press, 2004, pp. 101-20.

Mukherji, Subha. *Thinking on Thresholds: The Poetics of Transitive Spaces.* Anthem Press, 2011.

Munro, Ealasaid. "Feminism: A Fourth Wave?" *Political Insight,* vol. 4, no. 2, 2013, pp. 22-25.

O'Reilly, Andrea. "Matricentric Feminism: A Feminism for Mothers." *Journal of the Motherhood Initiative,* vol. 10, no. 1 and 2, 2019, pp. 13-26.

Pinkola Estes, Clarissa. *Women Who Run with the Wolves: Contacting the Power of the Wild Woman.* Random House, 1992.

Plath, Sylvia. *Ariel.* Faber & Faber, 1965.

Pope, Rob. *Creativity: Theory, History, Practice.* Routledge, 2005.

Scott, Linda. *The Double X Economy: The Epic Potential of Empowering Women.* Faber & Faber, 2020.

Smith, Sidone, and Julia Watson. "Introduction." *Getting a Life: Everyday Uses of Autobiography,* edited by Sidone Smith and Julia Watson, University of Minnesota Press. 1996, pp. 2-22.

Strachan, John, and Richard Terry. *Poetry.* Edinburgh University Press, 2011.

Thomassen, Bjorn. *Liminality and the Modern: Living through the In-Between.* Routledge, 2014.

Van Der Kolk, Bessel. *The Body Keeps the Score: Mind, Brain, and Body in Transformation of Trauma.* Penguin, 2015.

12.

Writing the Breast:
The Hyphenated Sign

Claudia Zucca

Screaming Milk

The spilt milk
I cannot feed
my body screams

Introduction

This chapter on the breast is interdisciplinary, crossing various genres from critical thinking in feminist theory, philosophy, psychology, medicine, and creative writing. It discusses the mind-body dichotomy to understand how the body has been widely disregarded and explores the concept of écriture, the notion of "writing the body," and the "felt, bodily sense" of writing. It aims to explore the difficulties inherent in discussions of the breast, particularly in breastfeeding contexts. Furthermore, it discusses the effects of breastfeeding issues in the context of mothering regarding the concept of the "good enough" mother (Winnicott). This chapter uses creative writing to help process, approach, engage, and explore the breast in multiple contexts. It uses autobiographical writing and poetry as a strategy to reevaluate and reposition the body and breast.

Studies on the Breast

Most studies on the breast are examined in contexts of feminism, maternal studies, medical research in cancer studies, and cosmetic and reconstructive surgery. Gal Ventura has explored maternal breastfeeding and its substitutes in nineteenth-century French art, Harriet Richard has discussed body image and reconstructive surgery, and Lea Vene has examined the way Western society objectifies women's bodies by exposing body parts. In studies relating to issues in breastfeeding, Erin N. Taylor and Lora Ebert Wallace have provided a framework for a comprehensive understanding of infant-feeding-related maternal guilt and shame. Their study is grounded in a feminist theoretical and psychological framework, which considers emotions of self-assessment. I avail of this latter study to help gain an understanding of the ways shaming and guilt shape the way women experience breastfeeding.

Most studies on the breast, as an area of research, are associated with discussions of illness. These tend to focus on biological and physiological processes, rather than the emotional, psychological and more subjective accounts. This positioning has led to a perspective of the breast as a problematic area of discussion. The reticence and reluctance to discuss the breast in all its connotations has hurt the discourse of the breast in diverse fields. Janet Price and Margarit Shildrick have argued that feminists have been reluctant to engage with the female body or have found it difficult to articulate a positive theorization of it (3). This chapter's objective is to explore and discuss the breast and engage with ideas about representing it in critical and creative terms. In this sense, creative writing allows writers to engage with sensitive material more openly and intimately. Writing in this context becomes instrumental in capturing the emotions connected to the breast and breastfeeding.

The Mind-Body Dichotomy: The Crisis of the Body in Western Thinking

Since classical times, the theorization of the relationship between mind and body has produced inadequate models of the body. The body in Western discourse has been epitomized as an absence, where the mind is more important than the body. It is as if the mind is a disembodied subject without corporeality. The problems in discussing the body stem

from the Cartesian view of the mind versus body dichotomy. In most Western epistemologies, the issue of what the body signifies has "continued along Cartesian lines as processes of dissecting, subjugating, charting and seeking to 'know' the fragile flesh through the knife-sharp instrument of the mind" (Nicholls 10).

What is evident is that the relationship between mind and body, and body and the self has taken on new and complex meanings and dimensions. At the end of the twentieth century, the notion of a corporeal absence and its abstraction has become a contested site for reimagining the body and its significance. We witness the emergence of "a comprehensive scientific effort to solve this ancient problem" in more invigorating terms (Solms and Turnbull 45). Interdisciplinary research in various fields, especially in consciousness studies, cognitive sciences, and feminist approaches, has led to a vision of the body in much more complex terms.

Writing the Body: A Bodily Felt Sense Writing

This section engages with critical theory to understand how creative writing may help to explore intimate discussions of the body and the breast. I draw on French feminists and from more recent current theories to understand how writing about the body can yield useful insights in the field of subjective experiences of the breast. Writing the body and about the body provides a framework in which to discuss and explore the breast.

The notion of writing the body carries echoes of the French feminist movement of the 1970s. French feminism helped shape and provide an awareness of the role of the body. The concept of the French term écriture feminine[1] derives from the work of Jacques Lacan (1901-1986) and was later revisited by Hélèn Cixous. Écriture is what produces "poetic language or text.... One could use the word 'scription' to convey the sense of contemporary écriture" (Kristeva, *Strangers to Ourselves* 19-20). Feminine scholars criticized and argued that Western writing is embedded in patriarchal values of the symbolic order and phallocentric tradition, which is viewed as rigid, fixed and linear (Birch et al.). Écriture feminine, in contrast, taps into the imaginary; it gives voice to the unstructured forms of the unconscious, the body, and the semiotic. The semiotic is associated with the maternal body. It manifests in rhythm

and tone and becomes a subversive force in writing (cf. Kristeva, *Revolution in Poetic Language*; Birch et al.). This chapter uses creative writing to draw on the semiotic realm, and at the same time, subvert the symbolic. Cixous has commented that "Writing is working; being worked; questioning (in) the between (letting oneself be questioned) of same and of the other without which nothing lives" ("The Laugh of the Medusa" 85-86). Writing in this context is also about living between societal norms and the feelings of one's own body. Writing allows the female writer to reconsider the way her body is construed. What does a woman do when her body does not respond to social norms and prescriptions? How does she cope if she is unable to respond to these norms? How does writing highlight these predicaments and aspects?

Writing the breast implies an exploration of a felt, bodily sense of writing, which connects to one's feelings and emotions. Celia Hunt and Fiona Sampson have coined the terms "felt, bodily sense of self" (cf. Nicholls). In their view, writing the body is a "bodily-felt" writing or writing that has "bodily self-presence" "underlying and informing the language we use" (Hunt and Sampson 30). These notions enhance an understanding of a "bodily self-presence," as well as an awareness and understanding of the body in creative writing that discusses the breast.

Autobiographical writing as a tool for self-help and discovery centres on the writer's subjective experience. It can tap into the unstructured forms of the unconscious, the body, and the semiotic, becoming that subversive force. Eugene Gendlin helps gain an understanding of the verbal symbolization of a felt experience. He suggests that "There is no necessity that language kill experiencing" (19). He sets out to "devise a method so that language can help us refer to our experiencing, help us create and specify aspects of it, help us convey these sharply or roughly" (19). He continues: "We can use any word in an experiential sense. We need not limit ourselves only to the word's logical and objective definition" (19). For Gendlin, both felt meaning and symbolization have fundamental functions in cognition. Gendlin's theory has similarities with Kristeva's notion of the semiotic. His notion of "symbols" functions in a similar way to Kristeva's "symbolic." For Gendlin, "Meaning is formed in the interaction of experiencing and something that functions symbolically. Feeling without symbolisation is blind; symbolisation without feeling is empty" (5). Gendlin, like Kristeva, sees the creative potential for the dynamic interaction of experiencing and symbolizing

felt, bodily writing.

The concept of writing the body, like many discussions of the body, is often a focus of contention. This is partly because these concepts elude rigorous scientific analysis and categorization. Susan Knutson argues that the discourse of writing the body has been criticized for its biological-metaphysical or essentialist definition of femininity (Knutson 5). Cixous explores the difficulty of defining a feminine practice of writing: "The difficulty will remain, for this practice can never be theorized, enclosed, and coded—which doesn't mean that it doesn't exist. But it will always surpass the discourse that regulates the phallocentric system" ("The Laugh of the Medusa" 883). Recent clinical research has suggested that there is a biological basis for the self, which arises from our bodily feelings and emotions. This self preexists linguistic and social constructions. What is evident is that the relationship between mind and body, and the body and the self, has taken on new and complex dimensions. Andrew Sparkes claims that because of the uncertain times in which we live, the body and the self "are increasingly coordinated within the reflexive project of self-identity," but he also points out that they are organized in a way that is the "exterior territories, or surfaces, of the body that symbolize the self at a time when unprecedented value is placed on the youthful, trim, sensual body" (464). We are exposed to the scrutiny of others as we observe the body of the other(s). In Sophie Nicholls's words, "We increasingly experience our bodies as the objects of our own and others' gaze" (11).

"Writing from the body," in certain contexts, conveys writing that stems from within. This type of writing works its way from beneath the surface, outwards. It is an opening up, revealing the self and the body in the writing process. This form also conjures up images of something tangible, present to the self, where the body is made visible, giving it presence and permanence. At the same time, the words conjure up imagery of one's inner world, where the psychological and emotional aspects of the self come to the fore, becoming visible. The notion of "writing on the body" invokes and conjures up ideas of bodily inscription, suggesting that something occurs to a body—on the body, takes place on a surface—the membrane and the skin of a physical body. Thus, writing on the body is a form of inscription that occurs on the physical surfaces of a text, body, and artwork. Bodies may be "marked" without also being either fixed by identity or defined by an essence (Frazer and

Greco 14-15). Yet the material body can become encoded and marked with signs of identity. Furthermore, it carries signs on both its surfaces and in its interior landscapes.

Poetry as a Strategy for Repositioning the Discourse of the Breast

This section provides a poetic framework to explore the breast in different contexts. It attempts to write the body, and the breast, through poetry, and in so doing, break the silence and taboo associated with the breast. The breast in this chapter is viewed as part of a wider context in the studies on the body. The difficulty of writing about the breast is a taboo of which we seldom speak, even in our private conversations.[2] This is because discussions on the breast draw attention to the body, the naked body, and bodily fluids. In this sense, it is a cause for shame and embarrassment.

In the public sphere, the uterus often defines gender. In the eighteenth century, the medical profession focused its interests on the breast as a moral, philosophical, and ethical study. However, in the nineteenth century, more focus was placed on the uterus and ovaries (Jodanova 161). The breast and the uterus are both seen as a sign of a woman's femininity, gender, and sexuality. In the private sphere, the breast also symbolizes a woman's role in the family. In this light, the breast is viewed as functional; it belongs to the realm of nurturing and feeding. This consideration emphasizes its physiological and biological nature. However, the act of breastfeeding is also very intimate and where mother and child may bond.

The breast is part of a complex whole. To write the breast is to write the body. To write the body is to write the personal and thus make it public. To write makes the personal a social and a political predicament. To write about the breast is to write about the self and the body, and also about one's emotions. It is in this regard that we can begin to make sense of the importance of the breast and the body in our everyday lives.

Whole Not Holes

I am this body
not these pieces
to poke and prod
to open and mould
I am these breasts
not just these holes

I am whole
even when cut open
but "you" see me as a hole
I see me as whole
a whole lot more than just holes

In this poem, the narrator highlights the way the breast is treated in medical contexts as "these pieces to poke and prod." The female body has been constructed within biomedical and bioethical discourses. In the poem, the breast is configured as a "whole" and not identified as simply "holes." The poet claims her breasts and, thus, claims her body. She refuses to be defined, nor does she wish to be endlessly poked and prodded. She envisions herself as "this body whole," even when there is a part missing. Claiming her body helps her to regain a sense of self and self-worth. We tend to forget that we are our bodies. Yet the question remains whether we truly own our bodies and/or how much we own. How many rights does a woman have over her body and her bodily choices?

The following poem is a brief exploration of illnesses of the breast. It highlights the way all types of illness related to the breast can affect a woman's psychological and emotional wellbeing.

The Lump in My Throat Is My Breast

I touch my breasts
for signs of life
but death is the lump in my throat
 in my breast

The lump in my breast
is in my throat
The lump is my breast

I choke on the lump in my throat
 the lump in my breast

This poem highlights the inability of the narrator to speak when dis-
covering that she has a lump in her breast. The lump in her breast has
moved to the throat. The inability to speak in the face of horror, also
reflects the silence surrounding illnesses of the breast, in both the
private and public sphere. Yet, it is through creative pursuits and outlets,
that the voice and body can become visible, and trauma negotiated on
the page. By writing the breast, and voicing the unspeakable, the body
is being liberated from oppressive silence and annihilation.

 The following poem explores the effects of surgical removal in the
case of breast cancer. How does one deal with such a loss of self and
body?

My Name Is Written on My Breast

I see the holes
the absence

I am no longer whole

I am a dumping site
a putrid wasteland

"you" must save me from my breast
from my rotting breast

but I am still me
my name is on my breast

I own the name on my breast

The poem reflects on the loss of a part of one's body, which links to a loss of self, defined as "an absence." The poet feels an incommensurable void. How can writing fill that void, that absence? Writing the breast makes visible the absence and the loss. Both are palpable. Writing names the unspeakable, unnameable horror: "putrid wasteland" and "my rotting breast." Writing the breast, in this instance, provides a space in which to explore the difficult themes of illness, breast cancer and the surgical removal of one's bodily parts. The poem reveals the way the inner and outer wound/s affect her sense of body and sense of self, her breast is envisioned as "an absence." It also creates an opening so that the horror may be explored and voiced. Thus, it enables a release of emotions. The poem explores the stigma of a body that has been maimed, disfigured, and scarred. The poet's body carries these visible signs, both on her surfaces and in her interior landscapes. Her breast becomes a site for inscription, where the material body is encoded with the visible signs of loss: "I am no longer whole" and "I see the holes." Here, the body can also be depicted as a hyphenated scar, a negative sign that marks. It is inscribed upon the body, and in the body, it is always working below the surface and on the surface, one's skin and one's façade. The scar "celebrates the wound and repeats the lesion ... adds something: a visible or invisible fibrous tissue that really or allegorically replaces a loss of substance which is therefore not lost but added to, augmentation of memory by a small mnesic growth" (Cixous, *Stigmata* xii-xiii).

But the wound is also a stigma. For Cixous, "Stigmata takes away, removes substance, carves out a place for itself" (*Stigmata* xii-xiii). The stigma rises from the scar. It is an extension of the wound itself: "The stigma conveys the strongest message, the most secret message ... the stigmatized person is singled out for exclusion and election" (xii-xiii). Yet the stigma represents not only destructive forces at play but also "a sign of fertilization ... germination" (*Stigmata* xiv) and creativity. The breast stigma, though viewed as a negative sign and incomplete, acting on behalf of a loss and silence, is an opportunity for the poet to explore emotions surrounding loss and illness through creativity.

In this instance, it is through writing that words acquire power, in the ability to rise from the incomplete hyphenated sign. Therein also lies the possibility of connecting because the hyphen is also a connective; it joins and reconnects. Thus, in owning one's shame, one must reside in that space, delve within the horrors of the scar and stigma to retrieve, and empower the self to reconnect with the self. It is in this sense that one can own one's beauty, even in one's endless imperfections. Naming the breast is a powerful act of owning one's body. That which was removed and taken from her is at once named and reclaimed: "My name is on my breast." Medical professionals can remove the putrid bits, but they cannot take away her name: "I own the name on my breast."

A Personal Narrative: Writing from the Breast

This section provides a personal narrative and testimony on the difficulties of breastfeeding and explores what this inability signifies on a personal and emotional level. This account of my narrative of childbirth begins in the county of West Sussex, near the shores of Worthing and Goring Beach. Becoming a mother represented a pivotal moment in my life. I had waited so long to have a chld, and it was finally going to happen. I discussed my pregnancy plans with my midwife, and I was keen to have as natural a birth as possible. I also decided not to have an epidural or any medication. Most importantly, I had opted to breastfeed my newly born child. Labour began four weeks before the due date. Everything was a blur. I rushed to the hospital in a taxi. The taxi driver helped me get to the entrance of the hospital. Labour lasted an eternal, everlasting thirty-four hours. I gave in. I had that cursed epidural. I felt excruciating pain as the physician tried to get the needles into my spine, numerous times. I cursed in several languages. Afrikaans, English, and Italian all mingled together in one voice: my strange birthing cry.

I finally gave birth at 7:45 p.m. to a beautiful baby. The midwife handed me my precious bundle. I held her close to my chest; I felt the deepest of connections. I do not know how much time went by before it was time for her first feed. I felt excited at the prospect and was looking forward to that special moment. The nurse was nearby, guiding me. She held my daughter and then placed her gently on my chest while I removed my hospital gown to uncover my breast. My baby's face was touching my skin. I could feel her soft body on my skin. It was time to

latch on to my breast. As soon as my baby girl started suckling my nipple, I winced. I felt very uncomfortable. I wanted to make it stop. I couldn't scream or I would scare my baby, so I screamed in my body. A rabbit was suckling my breast. What was happening to me? I could not do it. I could not feed my child. The nurse wanted me to try again. I became frantic. The midwife intervened to tell the nurse to stop insisting, as I could develop post-natal depression. I was overcome by so many emotions.

Many women in my position are not always that fortunate. They are pressured into breastfeeding, to the detriment of their emotional and psychological health, and suffer from post-natal depression, as a result. In one sense, I had been extremely lucky. Yet I had no name to describe what I was experiencing. I could not understand. How can you explain rejecting the most natural thing in the world? Why was my body not responding? Why could I not naturally breastfeed my child? What was stopping me from being the "good enough mother"? (Winnicott). I felt such guilt at not being able to feed her, but I had no time to properly think it through. I had just had a baby. The nurses prepared formula milk for me. I started to calm down. The nurse showed me how to hold my baby while I bottlefed her. I felt her little cheek on my skin, and her little hand was lying on my breast. That contact was our link, her hands on my body continued right up until I weaned her. That was our connection, our bonding started with her little hand on my breast.

I wanted to be that perfect mother, more than the good enough mother. Yet, I was far from that idealized vision of perfection. I had succumbed to an epidural and could not breastfeed. In other words, I could not perform the duty of a mother. In medical contexts, a woman's breast is considered as "being naturally made for feeding" (Stearns 318). The breast for me at that moment became a stigmatized site. I carried the scar of my disability—the shame, that inability to perform, like the hyphened scar, a negative sign, incomplete. I was a failure. I kept my secret hidden. For fifteen years, I held the stigma in my breast. My unused milk accumulated into a semi-solid liquid, which transformed into cysts.

Sour Milk

my breast
is dripping milk
my breast
houses soft milk
white pearly lumps
my breast
is now sour milk

I suppressed the shame I had to hide, behind a smile that longed to cry. But the shame never left my body. How much do I love you, child? I think not enough. I could not feed you through my own body. I could not nurture you. I substituted a breast for a bottle. You loved the bottle, thought it was my flesh. Yet the bottle saved me from my incompetence. It gave me the chance to provide you with sustenance. Some of the guilt dissipated because I managed to feed you, but the shame remained, scarred tissue never heals. I am now finally ready to break the silence, to speak the unspeakable, and to name the taboo that haunts me. I am ready to begin talking about the breast and my body. I am ready to write the breast.

Writing the Breast

you seek my *breast*
I feed you the bottle
you feel my *breast*
I am the bottle
you feel my *flesh*
in the bottle
I feel the shame
dripping from my *breast*
but the love is my *flesh*
the love is now the bottle

Female bodies have been constructed as leaky (cf. Shildrick and Price; Moore and Kosut). We are messy, unbounded, borderless, untamed wild women with unpredictable bodies. In anthropological fieldwork, cross-cultural experiences of a woman's body have been described as "polluting" because of the body's propensity to leak (Moore and Kosut). Leakiness contaminates logical, rational, and bounded spaces: "As the devalued processes of reproduction make clear, the body has a propensity to leak, to overflow the proper distinctions between self and other, to contaminate and engulf" (Shildrick and Price 3). I cannot always control what happens to my body. It defies rational and logical thinking. My leakiness is connected to being more fluid and flexible. My body extends and protrudes. I carry a child inside my body. We live through cycles, but these cycles can be interrupted and broken: I did not breastfeed. I bottlefed. In the unexpected turn of events, the irrational overturns the rational. One can try to imagine many reasons why women cannot breastfeed their children. I have spent several years pondering on that question. The issues of mothering are at the fore.

During my pregnancy, I had to go into therapy. I was petrified of becoming a monstrous mother. I plummeted into despair. With appropriate help, I realized that I was not my mother. Yet the fear of failure always lurked in the background. I never really knew how deeply her unloving and undoing of me would affect my body and my sense of self. It would influence every aspect of my life, even in my ability to breastfeed. There is something very delicate and intricate about the nature of the breast, about the way it carries, and holds the mother, the internalized mother and the child, within its structures, its tissue and skin. When the tissue is scarred, the holding space ruptures. Healing requires patience and tending to our inner landscapes.

Guilt and Shame in Breastfeeding Practices

This section analyses guilt and shame in breastfeeding contexts. Taylor and Wallace suggest that for many new mothers, guilt and shame are not unfamiliar territory (77). They argue that maternal guilt and shame, which surround issues on breastfeeding have not been properly and "adequately addressed by either feminist critiques of breastfeeding advocacy" (77). In the field of feminist studies, scholars have also noted that shame and guilt disproportionately affect women. These two

emotions determine a woman's breastfeeding practice, and in a sense, they shape the decisions women make, without the realization that they are being conditioned by medical ethical practices to behave in a certain manner, often inducing them to feel shame and guilt. Yet breastfeeding advocates will tend to defend their efforts. On a psychological level, Taylor and Wallace suggest that guilt is not as destructive as has been previously perceived. Shame, in contrast, is identified as being much more destructive (77). Yet the discourse of shame is controversial. They argue that shame is "inappropriate as a tool of breastfeeding advocacy for strategic, moral, and feminist reasons" (77-78). Feelings of shame and guilt extend not only to those who are unable to breastfeed, but also to those who breastfeed, as well as breastfeeding in public spaces. In this regard, the breast takes on connotations of the grotesque, in the gaze of the "other." The breast must be hidden in public, for it causes unease. The act of breastfeeding is primordial and primitive. Yet in modern Western societies, showing the breast in public spaces conjures up images of the naked body, and is seen as an organ of sexual pleasure. Breastfeeding is seen as inappropriate because it evokes emotions. Thus, it must be confined to the domain of the private sphere.

Advocates for formula-feeding mothers suggest that mothers tend to feel more than guilt. In their view, other emotions come to the fore, such as those of "anger" and "regret" and a feeling of failure on behalf of the medical system to adequately support breastfeeding practices (Taylor and Wallace 79). Even those women who do make informed decisions on breastfeeding, many may still lack the support they need to breastfeed successfully. They may also be constrained by social, cultural and economic circumstances or health issues that make breastfeeding difficult (79).

How can women in societies come to terms with breastfeeding choices? Women can define what it means for themselves to be good enough mothers, so that "they are empowered to incorporate a sense of self-concern" (76) The ideals of self-concern cannot fully eliminate feelings of shame and guilt, but they may help to lessen the potential for negative feelings inherent in breastfeeding practices. Thus breastfeeding advocates and feminists must work together to acknowledge and challenge shame in breastfeeding practices. It is relevant that they begin by naming, revisioning and resisting shame in all its forms and begin to facilitate an awareness and understanding of self-concern. It is

important to help mothers "redefine what it means for themselves to be good enough mothers, and work to ensure that the "process of redefinition empowers women to incorporate a sense of self-concern" (92), self-care, self-awareness, and self-interest.

Conclusion

This chapter has discussed the body, particularly the breast. The study of the body is complex due to the perceived dichotomy of the body and mind split. The breast, like the body, is also an area of complexity and tension for it invokes notions of illness and uneasiness. On another level, the breast also conveys ideas of maternity, and conjures up images of sexuality.

This chapter has attempted to write the breast in different contexts by bringing together an array of critical perspectives, interspersed with personal narrative and poetry. I have suggested that the breast as a problematical site, is a hyphenated scar. The breast stigma is a scar—an extension of a wound. In this sense, the breast is envisioned as a negative sign, incomplete. Yet stigmas are not only destructive forces. They are also grounds for active fertilization and creativity. Writing and art forms may provide us with alternative modes for evaluating, discussing, and exploring the breast by allowing writers, artists, and nonartists (in creative writing settings and journal writing) the ability to write, by rising from the incomplete hyphenated sign and connecting words on paper, and by creating art forms. In so doing, one can delve into the darkest of places to find one's wounded self. Writing is self-empowering. Writing and art are a possibility, a way forward, for freeing the voice and the self from the burden of silence.

My findings suggest that in breastfeeding contexts, feelings of guilt and shame persist in both bottlefeeding and breastfeeding practices. It is only by naming and resisting shame that we can begin to foster an awareness and an understanding of self-concern so that we, as mothers, can redefine for ourselves what it means to be good enough mothers.

Today, we need to start envisioning diverse models of representation and new ways of repositioning the breast to reconsider its role in different and alternative modes in maternal studies, feminist studies, creative arts and studies of the body by openly discussing the taboos surrounding the breast. It is indeed possible to write the breast.

Endnotes

1. Julia Kristeva's semiotic language is not identical to écriture féminine. The main difference lies in the assumption that the semiotic "has the power to operate as a disruptive force within the symbolic order" (Birch et al. 35). On the other hand, the proponents of écriture féminine, view écriture feminine as "an order of language existing outside patriarchal discourse, on the margins of culture" (35).

2. This difficulty has also been identified in scholarly research and feminist studies.

Works Cited

Birch, Dinah, et al. *Language and Gender: Literature in the Modern World.* The Open University, 1991.

Cixous, Hélène. "The Laugh of the Medusa." Translated by Keith Cohen and Paula Cohen. *Signs,* vol. 1, no. 4, 1976, pp. 875-93.

Cixous, Hélène. *Stigmata: Escaping Texts.* Translated by Eric Penowitz. Routledge, 1998.

Gendlin, Eugene T. *Experiencing and the Creation of Meaning: A Philosophical and Psychological Approach to the Subjective.* North Western University Press, 1962.

Frazer, Mariam, and Monica Greco, editor. *The Body: A Reader.* Routledge, 2005.

Hunt, Celia, and Fiona Sampson, editors. *The Self on the Page: Theory and Practice of Creative Writing in Personal Development.* Jessica Kingsley, 2004.

Jodanova, Ludmilla. "Natural Facts: A Historical Perspective on Science and Sexuality." *Feminist Theory and the Body,* edited by Janet Price and Margrit Shildrick. Routledge, 1999, pp. 157-168.

Knutson, Susan. *Narrative in the Feminine: Daphne Marlatt and Nicole Brossard.* Wilfred Laurier University Press, 2000.

Kristeva, Julia. *Revolution in Poetic Language.* Translated by Leon S. Roudiez. Columbia University Press, 1984.

Kristeva, Julia. *Strangers to Ourselves.* Translated by Leon S. Roudiez. Columbia Press, 1991.

Moore, Lisa J., and Mary Kosut. *The Body Reader: Essential Cultural and Social Readings.* New York University Press, 2010.

Nicholls, Sophie. *Writing the Body: Ways in Which Creative Writing Can Facilitate a Felt, Bodily Sense of Self.* Dissertation. University of Sussex, 2006.

Price, Janet, and Margrit Shildrick. *Feminist Theory and the Body: A Reader.* Routledge, 1999.

Solms, Mark, and Oliver Turnbull. *The Brain and the Inner World: An Introduction to the Neuroscience of Inner Experience.* Other Press, 2002.

Sparkes, Andrew C. "The Fatal Flaw: A Narrative of the Fragile Body-Self." *Qualitative Inquiry,* vol. 2, no. 4, 1996, pp. 463-94.

Stearns, Cindy A. "Breastfeeding and the Good Maternal Body." *Gender & Society,* vol. 13, no. 3, 1999, pp. 308-25.

Taylor, Erin N, and Lora Ebert Wallace. "For Shame: Feminism, Breast-feeding Advocacy, and Maternal Guilt." *Hypatia,* vol. 27, no. 1, 2012, pp. 76-98.

Winnicott, Donald Woods. *Playing and Reality.* Tavistock, 1971.

Bloody to the Elbows

Jennifer Cox

Five poems on mothering through birth trauma

1. Portrait of a Mother in the ICU
2. Salad Lunch
3. Dolphins
4. My Sons
5. motherBirth, Reenvisioned

1. Portrait of Mother in the ICU

Four days postpartum, ICU room three
A tube down my throat for breathing
Another down my nose, for eating
Six IVs in each arm, one leaking
A hand tied to the bed so
The IV machine would stop beeping

The smell of spoiled breastmilk and
Four days of unwashed sweat
My skin, yellowed and bruised
My red blood cells, spent

The cloth across my breasts and
My bloody underwear of mesh
My only clothing, by my request
My belly so swollen the X-ray tech
Says, "Any chance she's pregnant?"

2. Salad Lunch

No one told me
I might emerge from childbirth as if
Returning from war
Bruised and bleeding
Pock-marked with scars
The battleground of my body

The soft pink pastels of pregnancy
Cleaved into the reds and whites of birth
The only thing so muted about birth trauma
Are the stories we don't tell about it

"Mine was bad too" some whisper later
Holding my hand for a fleeting squeeze, then
Returning to their salad lunch and
The more palatable topic of
their kid's most recent milestone

Why didn't they warn me?
Why hadn't they shouted it at the baby showers?
Why hadn't they tucked a note between the gifted blankets:
"It doesn't always go well"

3. Dolphins

In the bath, you ask to breastfeed by
Smothering your face in my chest
Stating your needs

I pull you towards me
Nipple to your mouth
You suckle, eyes meet mine

Little feet splashing in the water
Like dolphins making mischief
In a sea of fish, joyful feasting

And my mind goes to the first time
Trying to feed you at the hospital, me
Asking my body for just one more thing

You screaming from hunger
My breasts bursting, the nurse's meditations:
"Nipple to mouth, nipple to mouth"

My breasts too forceful, your latch
Too weak, yet the milk eventually
Flowed, enough to fill us both

Now, we nurse in the water
and play in gratitude of
Our healing bodies

4. My Sons

Look for each other upon waking
Play rough and gentle and silly
Sing out of tune together
Only want to play with
Whatever toy his brother has
Share slobbery kisses, feel better kisses
open-mouthed kisses
Upside-down through the crib kisses
I'm-yuckier-than-you kisses
Barely-not-a-bite kisses, Goodnight kisses

All my doubting whispers of "Was it worth it?"
Devoured in those kisses

5. motherBirth, Reenvisioned

Alone in a dark room, contracting
Light shining from my stomach out between my legs
Push, push, push, heard only in my head
 Silently, I— birth
My own mother, sixty years young, in cardigan and corduroys
Light shining from beneath her wool, she
Shakes off the amniotic fluid like coming in from the rain,
 A lifetime of practice, she is a Sentinel, a Guide, as
The next urges come and more light shines through
Emerges one grandmother, then the other
 Eighty years strong, pleated pants and glasses
 Disjointed twins, reunited at my waist, they
 Expand the room with light
As the quartet of great-grandmothers slide out
In formation, a
 Canal of burning candles around me

In formation, the

> Great-greats and great-great-greats and the Great-great-
> greatness emerge

From my womb, magnificent, powerful,

They are my midwives, conducting my primal groans in

> Skirt-swaying symphonies, earth-moving
> Rhythms flowing, flows synchronizing
> Moaning, moaning, mourning
> My language, our lost languages
> The languages only
> Our sinews speak
> Untranslatable words, that I
> Call back from between my legs, my labia
> To the long canal of my ancestors

Making the room bright and we push and push and puuuuuuuuuuuuuush
until:

> A new mother is born, I

> Cradle her through the afterpains

> Bloody to the elbows, my mothers
> Catch my placenta
> Our blood drips through their hands

14.

Abreast of Things

Hazel Katherine Larkin

Introduction

Content Warning: This article references child sexual abuse, self-loathing, and self-harm. Please exercise self-care if or when you choose to read it and access mental health support if you feel you need it.

As a survivor of years of childhood sexual abuse, I did not always love my breasts. They were the unwilling recipients of unwanted male attention. I did not want them. I tried to cut them off. I was not successful, but it took a while before I was glad that I had been unsuccessful. Mothering my children and moving from hating and harming my breasts to loving and appreciating them was a journey that took more than two decades.

This piece—which is both textual and a theatre performance (extracted from a longer piece "Body of Evidence")—explores and examines my relationship with my breasts. As such, it is very much an autoethnographic article. It details the damage (cosmetic and otherwise) that I inflicted on my breasts when I was a teenager, explores the theme of self-harm as a way of dealing with child sexual abuse, and reveals the healthy relationship I enjoy with them now, not least because using my breasts for their intended purpose brought me much psychological and emotional healing.

This is a piece of work that celebrates triumph over trauma by explicit—but not gratuitous—detailing of the journey from victim to victor. It is also a piece of work that will resonate with many women

and—it is my fervent desire—will offer hope to many of them.

The link to a recording of the piece is here: https://vimeo.com/687498 576/2498f2e69a

Methodology

I am autoethnographer. Most of my published, and performed, works to date have been autobiographical or informed by discussions with others who have similar histories to mine. As an autoethnographer, I need to insert myself into my research. That is not just valid; it is required (Adams et al). Or as Carolyn Ellis et al. put it: "When researchers do autoethnography, they retrospectively and selectively write about epiphanies that stem from or are made possible by, being part of a culture and/or by possessing a particular cultural identity."

Autoethnography is a method of research that describes and analyses ("graph") personal experience ("auto") to understand cultural experiences ("ethno") (Ellis et al.). Autoethnography is a research approach that puts the self at the centre of cultural analysis. This method produces meaningful, accessible, and evocative research grounded in personal experience. It is research that sensitizes those to whom it is disseminated and by whom it is consumed (readers and other audiences) to issues of identity politics, to experiences shrouded in silence, and to forms of representation that deepen our capacity to empathize with people who are different from us (Bochner, "Autoethnography"). Or as Heewon Chang asserts, autoethnography "transcends mere narration of self to engage in cultural analysis and interpretation" (43). Autoethnography also demands that we "observe ourselves observing" (Holman Jones, Adams, and Ellis 10).

Writing personal stories makes "witnessing" possible (Denzin; Ellis and Bochner, "Analyzing"). It provides participants and readers with the opportunity to observe and testify on behalf of an event, problem, or experience (Greenspan; Rogers) and allows a researcher to identify other problems that are cloaked in secrecy (Goodall), such as the subject of this article.

Breasts

Breasts are more controversial than, perhaps, they should be. Males and females are born with the same breast tissue, ducts, and nipples. It is only when puberty arrives that hormones prompt the physical changes that take place in female breasts. These changes include the laying down of fatty tissue to enlarge the size of the breasts. Hormonal changes in females are also responsible for the increase in prolactin, which triggers the production of milk.

Contemporary Western cultures code female breasts as erotic, and there are many theories surrounding why, including suggestions that they are sexually appealing because they are a result of sex hormones and sexual development.

My Breasts

I have magnificent breasts. I know it's probably immodest to say so, but it's true. I am delighted to be able to say so. I am delighted to be able to delight in them. For a long time, I despised them.

The first tattoo I got, aged seventeen, was on my breast. It has not aged well, but I would not have it removed or repaired. Done in black, it is a Celtic knot and is now a bit droopier—and slightly more elongated—than it was when I was a teenager. I got this tattoo as a gift to myself. The idea, then, was that it would detract attention from the scars on my breasts. I like to think my ploy worked, but there is always a possibility that I just have really good healing skin. Perhaps if I had waited a few years, the scars would have faded sufficiently to render the tattoo unnecessary.

The scars are still there, but they are not as visible as they might otherwise be. Sometimes, I rush to fix something when holding firm would have yielded the same, if not better, results.

That is a legacy, I suppose, of being a fixer: As a "fixer," I was raised to solve everyone's problems, raised to believe that inaction is passivity, indecision, and lack of will or caring. But sometimes inaction is just inaction. Sometimes holding firm and waiting for the result is the result. Or, at the very least, is the best approach.

Just as the tattoo is a "fix" so too are the scars themselves. They are the result of self-harming. Often ahead of my time, I was a self-harmer

before the phrase was even in use. The word used back in the 1980s and early 1990s was "cutter." And my goodness I applied myself to living up to that title. My favourite target was my breasts—the most obvious (and by that I mean the most visible) cause to my young mind of the sexual abuse that was being inflicted on me.

Part of me thought that if I could just perform a DIY mastectomy, no one would ever sexually assault me or rape me again. For a start, I hoped that my two elder brothers would ignore me because I would no longer be visibly different; I would no longer be female enough for them to be interested. Self-harming—cutting—had several advantages. Others have documented the psychic relief of cutting a piece of flesh, the physical hurt giving relief to the psychic pain. There is a satisfaction to being able to point at a wound and say, "That's why I'm hurting. That's the source of the hurt." Even though it is not.

For those fortunate enough never to have had the urge to cut, I will attempt an explanation: The internal pain and hurt and turmoil smoosh around inside you. It feels like bees buzzing in your head and driving you to the brink of insanity. But you can also feel it in your body.

You can feel it in your chest as a fizzy feeling—but not a nice fizzy like you get in your mouth when you eat sherbet. It is a disruptive fizzy feeling. It feels like cockroaches have hatched inside you and are flying around, trying to escape. Then those cockroaches give up trying to escape and start to consume you. They bat against your carcass from the inside out, and you can feel it. You can feel the buzzing, and the batting, and the biting. You have to make that stop. You have to make that sensation go away. So, cutting helps.

Self-harm is also a punishment. Sexual abuse is sexual; it targets the sexual areas of the body, and it places shame upon the victim. We feel disgusted by our bodies, and their sexuality, and their sexual appeal. We endure shame for having a body that elicits sexual excitement in abusers. We often feel an overwhelming need to punish our bodies simply for being; and for being this thing that attracts abuse to itself. It deserves pain. It deserves pain for being so shameful, ugly, and repellent, while at the same time being a source of attraction for abusers. Abusers would not abuse if you did not exist. Cutting off what attracts the abusers punishes you for attracting them. It never occurs to you that it might also be a way of punishing them.

On a practical level, it's easy. Think about it. If you want to do a bit of damage to something, you need to grab a hold of it. Even back in the days when I was skinny, I could grab a handful of boob and hold it steady while I hacked away. I couldn't have done that with a wrist.

Once I had stopped the worst of the cutting, I was left with scars that I was ashamed of, and that I was worried about. I worried that they would be the first thing someone would see or notice about my exposed breasts. It was then that I decided to give them a gift. That is what the tattoo was intended for. It was a way of making it up to my breasts for making them ugly—a way to prettify them and take the attention away from the scars they bear.

Permanent Structural Damage

Apart from the scars, and the tattoo, I have managed to do some permanent damage. Cysts have formed under the scar tissue where I cut myself. Sometimes, they get painful, but I am lucky that they are self-draining, so they do not require medical intervention. I did have them aspirated when they were initially diagnosed following my first mammogram when I was twenty-seven. Memories of that first breast exam always make me smile. I know no one has happy memories of having their mammaries examined but bear with me.

There I was, all of twenty-seven, not long married (for the second time), and I noticed I had a leaky left breast. A day or so later, I saw my general practitioner, and she recommended that I see a breast specialist. Within a week (healthcare in Singapore is superb), I was in a private hospital, waiting for my first mammogram. In advance of that, however, an ultrasound imaging of my breasts was ordered. The technician came in and introduced herself. With my breasts exposed, I turned my head towards the screen, waiting to see whatever I might be able to see on it. Picking up the bottle of gel, the technician said, "Oh no. That's not right. Excuse me, just one moment please," and she left the cubicle. For thirty seconds or so, I lay there thinking that she was such an expert at her job that she was able to tell, just by looking, that there was something wrong with my bosom. I assumed she'd gone to find a colleague to confirm her suspicions.

When she returned, however, she was still alone.

"Sorry," she said as she applied the gel to my skin. "Just the other one was cold."

In this facility, the gel used for ultrasounds was heated up in a row of baby bottle warmers, and the one she'd first brought in to use on me wasn't warm enough. Lying there, being scanned, all I could think was, "I have arrived."

The ultrasound and the mammogram afterwards showed nothing sinister. Thank God. I just happen to have cystic breasts, and the cysts have formed under the wounds I inflicted on myself.

DIY mastectomies are two of the few things I am glad I failed at. I am glad I never managed to chop my breasts off. Far from being terrible appendages that deserved to be hated, they are wonderful, beautiful, magnificent, life-giving, and life-sustaining sparáin.[1] It may have taken me many years to arrive at this opinion, but it is empirical and evidence-based and the experiments have been replicated more than once, rendering the same findings.

Not only did I breastfeed my own two girls—my youngest until she was five and a half—I contributed for about eight months to the human milk bank in Fermanagh. As a result, I helped scores of other children in the process. I mention this not because I think it was a worthwhile thing to do but because it was hugely useful in my healing journey. My body was suddenly doing something right. It was suddenly being useful and suddenly being helpful to others because I chose it to be. That was empowering. As an unexpected benefit, I was teaching my daughters the concept of Seva. This is the principle of 'selfless service', and is a central tenet of Hinduism. Essentially, it is the concept of doing something, selflessly, for another, without expectation of reward.

My children learned that we are all members of the human community, that we are all interconnected, and that it is important to do what we can for others whenever and wherever we can. They got that information—quite literally—with their mother's milk. When I was contributing to the milk bank, there was an order, akin to a ritual, to the preparation of my contributions. I sat at the table every morning, with my daughter on one breast and a manual breast pump on the other. As Kashmira sucked, my other breast gave up its liquid love. The milk-bank milk was then put into special, sterile bags and cooled, then frozen, until I had enough to fill the special polystyrene box that was then taken to the bus station in Dublin's city centre. There, it went on the bus where

the driver would go out of his way (he went off his designated route) to ensure that the milk was delivered to the milk bank.

Within a few weeks of my starting to collect milk for the bank, my eldest daughter started to call it "milk for the sick babies" and treat it with reverence. Ishthara had once been a "sick baby" herself; she was born at twenty-eight weeks in India and never expected to survive. She couldn't suck when she was born, so to get my milk into her, I expressed it and gave it to her from a bottle. She never suckled from my breast, but my milk did save her life. I also used it to combat her eye infections, heal some skin irritations, and treat her gastrointestinal illnesses while she was a tiny baby.

In the Irish language, we do not talk about breastfeeding. We talk about "beathú cíche," literally, "giving life with the breast." This is because my foresisters knew that the breast is about more than just food; it is about nurture, comfort, safety, reassurance, treating illness, and the continuous loop of knowledge exchange between the breastfeeding dyad.

Conclusion

Child sexual abuse has profound effects on victims/survivors/victors. Many of these are already well documented in the literature. Perhaps less well known is the proclivity some survivors have for targeting their breasts as a site for self-loathing.

Healing is not linear, and it is never complete. It is, however, possible to heal certain parts or to heal certain areas of damage—physical and emotional. Some ways of healing are more of a reclamation than others and occur almost by stealth, as is revealed in this chapter. Autoethnography is employed as a methodology to detail the decades-long introspective voyage from hating specific sexualized body parts (the female breasts) to loving them.

Endnotes

1. Sparáin is the Irish word for "purses."

Works Cited

Adams, Tony, editor. *Handbook of Autoethnography*. Routledge, 2013.

Chang, Heewon. *Autoethnography as Method*. Left Coast Press, 2008.

Denzin, Norman. *Performance Ethnography: Critical Pedagogy and the Politics of Culture*. Sage, 2003.

Ellis, Carolyn, et al. "Autoethnography: An Overview." *Forum Qualitative Sozialforschung / Forum: Qualitative Social Research*, vol. 12, no. 1, 2011. Available at: https://doi.org/10.17169/fqs-12.1.1589.

Ellis, Carolyn, and Art Bochner. "Autoethnography, Personal Narrative, Reflexivity." *Handbook of Qualitative Research*, edited by Norman Denzin and Yvonna Lincoln, 2000, pp. 733-68.

Ellis, Carolyn, and A.P. Bochner. "Analyzing Analytic Autoethnography: An Autopsy." *Journal of Contemporary Ethnography*, vol. 35, no. 4, 2006, pp. 429-49.

Goodall, H.L. "My Family Secret." *Qualitative Inquiry*, vol. 14, no. 7, 2008, pp. 1305-08.

Greenspan, Henry. *On Listening to Holocaust Survivors: Recounting and Life History*. Praeger, 1998.

Rogers, Kim Lacy. "Lynching Stories: Family and Community Memory in the Mississippi Delta." *Trauma: Life Stories of Survivors*, edited by Kim Lacy Rogers, Selma Leydesdorff, and Graham Dawson, Transaction Press, 2004, pp. 113-30.

15.

Untitled

Laura Simon

I am forty years old. I have two children and living in a relationship for over sixteen years. I have been working as a teacher of politics, French, and German in high school. Last year, I finally fulfilled my dream, and I am doing now what I always wanted to do and what I really love: art. I am currently studying at the University of the Fine Arts in Berlin.

I deal artistically mainly with the theme of regretting motherhood and the role models of women in contemporary Western society. I try in my work to express the hidden feelings of women, especially mothers, such as regret, fear, overload, and longing.

It is my concern to encourage women to free themselves from the preconceived expectations that society and family consciously or unconsciously place on them.

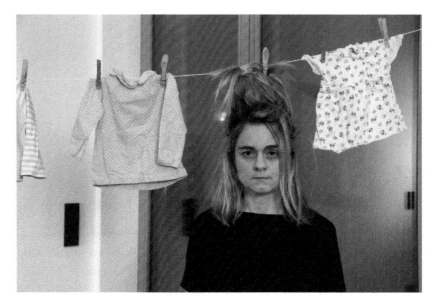

Figure 1. *Untitled*, 2021, digital photography

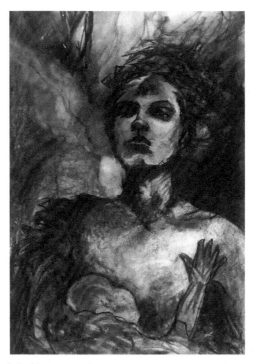

Figure 2. *Untitled*, 2020, watercolour and carbon on paper 49.8 x 70 cm

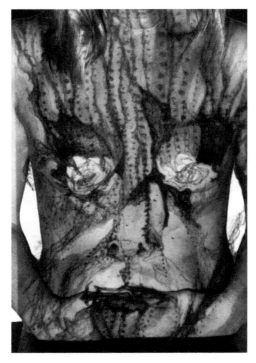

Figure 3. *Occupied,* 2021, projection: drawing on body, digital photography

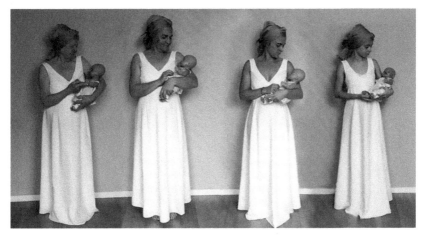

Figure 4. *Caught,* 2021, photo montage

16.

"There Must Be Something Good about Me": Dystopian Satire, Maternal Resistance, and the Undoing of Normative Motherhood in Jessamine Chan's *The School for Good Mothers*

Andrea O'Reilly

This collection aims to inspire feminist representations of maternal power, creatively challenge the often stifling and oppressive representations of mothers and motherhood as either good, bad, or monstrous, and curate images and writing into a lively book that will bring readers inspirations, new ideas, new perspectives, and joy. The title *Wild with Child* suggests that the chapters of the collection will deliver empowering and celebratory narratives about how we imagine mothers and motherhood that exist outside of, or in resistance to, the institution of motherhood.

Given the intent of the collection, my selection of the novel *The School for Good Mothers* (2022) by Jessamine Chan may seem an odd choice. In this rather gloomy novel, Frida, the central character, loses custody of her eighteen-month-old daughter Harriet after leaving her alone for a couple of hours and is punished with a year-long sentence at a state-run

institution that will train Frida to be a good mother and determine whether her daughter will be returned to her. A novel that recounts the harrowing and unscrupulous surveillance of mothers who are doomed to failure certainly does not seem to belong in a collection calling for fun and fresh imaginings of feminist maternal power. However, while *The School for Good Mothers* does not seem to be a novel about feminist maternal power, nor does it present its central mother Frida as a triumphant mother outlaw, the novel does dismantle heteronormative, classist, ableist, and racist tropes of mothers and mothering and in so doing delivers a formidable critique of the institution of normative motherhood.

In an interview with Margaret LaFleur, Chan comments that she thinks of Frida's story "as a quest. At its heart, it's about a mother fighting to get her child back." Through its decisive and derisive satire of what is seen as normative motherhood, and in Frida's ultimate resistance to it, *The School for Good Mothers* undoes this motherhood to enact feminist maternal power and create a mother outlaw who is wild with child.

This chapter will explore this undoing through an examination of the novel's critique of the institution of motherhood through negative satire, and exploring Frida's resistance to it will show how the novel reenvisions and renames the meanings of the good mother. Indeed, Frida realizes, despite her supposed shortcomings, "that there is something good about me," and by doing so, she can undo the pervasive binds of motherhood, as others think it should be.

"To Raise the Stakes and to Capture [the] Dynamics" of the Surveillance and Judgement of Mothers

When asked in an interview what drew her to the topic of motherhood, Chan explains: "I was wrestling with parenting culture and simply becoming a mother. I had it on the brain but I wasn't ready; I was scared" (qtd. in Borrelli). She elaborates: "The pull toward this subject matter came from my intense anxiety about whether to have a baby" (qtd. in LaFleur). Feeling ambivalent and anxious about motherhood, Chan then read an article in *The New Yorker* by Rachel Aviv about a mother who lost custody of her three-year-old son after leaving him alone at home for a few hours. After she read the article, Chan "felt a kernel of rage for this mother" (qtd. in Borrelli) because "the system was judging this immigrant mother's parenting, her personality, her way of communication,

and her depth of feeling by very American Western standards" (qtd. in Cook). Chan explains she then "went down the rabbit hole of reading about moms who had lost custody of their children" (qtd. in Burton). She elaborates: "I was really shocked.... You would think that the parents who get into trouble with Child Protection Services ... have beaten their children ... but it turns out that for the majority it is for the really broad category called neglect, which can mean all sorts of things. And in some cases, it just means poverty" (qtd. in Burton). Furthermore, what particularly struck Chan was "how much it was impacted by race and class and how much of the surveillance they were under by police and the community was influenced by race and class" (qtd. in Burton). In writing the book, as Chan explains, "[She] wanted to at least gesture toward those real-life dynamics ... [and use satire] to raise the stakes and to capture those dynamics" (qtd. in Burton). Once Chan had her daughter, she explains that "The book was a place where I could store all my questions and thornier feelings; where I could think about things in our culture that troubled me" (qtd. in LaFleur). What particularly troubled Chan and what she sought to explore in her book was "modern American parenting culture" (qtd. in Cook), which is oppressive and causes mothers to "self-police" (qtd. in Miller). Chan elaborates:

> I feel I was just working out personal questions with the story, because the fear that was driving the writing of the book was just really me being really afraid of having a baby and becoming a mom and taking on that responsibility and changing my life. So I definitely felt like the book was a way to process all the fear and pressure ... the external cultural pressure but also all this internal pressure to feel loving and joyful and grateful and patient at every single moment. And then I had my baby, and then I was actually living in this hyper-intensive parenting that I had been satirizing. (qtd. in Cook)

Though not named by Chan, this oppressive, hyperintensive parenting is precisely and specifically, the institution of normative motherhood that is derived from white, Western, and middle-class norms. This defines mothering as natural to women and essential to their being, positions the mother as the central caregiver of her biological children, and assumes that children require full-time mothering. This good mother is nurturing, altruistic, patient, devoted, loving, and selfless and always

puts the needs of her children before her own. She is available to her children whenever needed, and the children are the centre of her life.

Sharon Hays describes the contemporary conversations of normative motherhood as "intensive mothering" characterized by three themes: First, "the mother is the central caregiver"; second, "mothering is regarded as more important than paid employment"; and third, "mothering requires lavishing copious amounts of time, energy, and material resources on the child" (8). Moreover, intensive mothering "tells us that children are innocent and priceless, that their rearing should be carried out primarily by individual mothers and that it should be centered on children's needs, with methods that are informed by experts, labor intensive, and costly" (21). Intensive mothering dictates the following: 1) Children can only be properly cared for by the biological mother; 2) this mothering must be provided 24/7; 3) the mother must always put children's needs before her own; 4) the mother must turn to the experts for instruction; 5) the mother must be fully satisfied, fulfilled, completed, and composed in motherhood; and finally, 6) the mother must lavish excessive amounts of time, energy, and money in the rearing of her children. Mothers who, by choice or circumstance, do not fulfill the profile of the good mother—they are young, poor, or racialized, do not follow the script of good mothering, or work outside the home or raise children communally—are deemed bad mothers in need of societal regulation and correction. What is interesting to Chan, and is explored in her novel, is this regulation and correction: how normative motherhood is enacted and enforced in and by judgement and surveillance. As noted by Kim Brooks, author of *Small Animals: Parenthood in the Age of Fear* (a book read by Chan when she was writing her novel): "[All mothers] feel watched and judged. [All] wonder who is doing it the right way; all feel guarded and anxious; [we all] evaluate someone's mothering" (55). *The School for Good Mothers*, Chan emphasizes, is "about the control, judgement, and surveillance mothers experience and how much of that is based on race and class, and how unjust it is" (Miller).

The novel opens with the words that all mothers dread: "We have your daughter," left on Frida's voicemail by the police (1). The reader learns that Frida went to work leaving Harriet (her daughter) alone in their home for two hours. A neighbour called the police when they heard the baby crying. Child protection services (CPS) was notified, and Harriet was placed in the care of Frida's ex-husband and his wife. Frida

explains to all who will listen that "it was a mistake" (5): She had been up since 4:00 a.m., the article she was working on for her job was overdue, and she went to work for a needed file and lost track of time. At her visit with her social worker, Frida remarks, "I'm not going to pretend I'm some perfect mother, but parents make mistakes. I'm sure you've seen much worse" (13) and stresses that: "She's not the same as those bad mothers in the news. She didn't set her house on fire; leave Harriet on a subway platform; or strap Harriet into the back seat and drive into the lake" (12). She was simply "overwhelmed, didn't mean do to do [it], and messed and screwed up" (12). Later, Frida wants to tell the court judge that "Harriet was not abused; was not neglected; that her mother just had one very bad day"; she asks "the judge if he's ever had a bad day" and explains to him "that on her bad day, she needed to get out of the house; out of her mind, trapped in the house of her body; trapped in the house with Harriet" (13). Nonetheless, Frida is charged with abandonment and told that she will undergo a psychological evaluation. Harriet will receive therapy, there will be three supervised visits over the next sixty days, and Frida will be put under surveillance in her home under a newly established CPS program. Later that week, CPS installs cameras in Frida's house and her calls, texts, voicemails, Internet, and app use are tracked (20). CPS assures Frida that no cameras will be installed in her car or at her work because their focus is her home life and that they will use this footage "to analyze her feelings" (20). And by way of this footage, "decisions will be made more efficiently: They'd be able to correct for subjectivity or bias [and] implement a set of universal standards" (21). Here begins Chan's critique of "the idea that things like devotion and affection might be 'measured' according to some universal standard [of motherhood]" (qtd. in Stigler) to be later and fully developed upon Frida's arrival at the School for Good Mothers.

After the supervised visits with Harriet end badly—during one, Harriet bites the social worker, and during another, she works herself into a frenzy until she has a nosebleed—and one appointment with her psychologist when he calls Frida defensive for explaining to him that her Chinese upbringing cannot be judged by American standards, Frida learns that she will be sentenced to a year at a live-in facility, where she will undergo instruction and training. The judge decrees that the surveillance footage, emails/phone calls, and visits with her daughter and the psychologists show "feelings of resentment and anger, a stunning

lack of remorse, a tendency towards self-pity, narcissism, with an emotional orientation directed inward, rather than toward her child" (76). In other words, Frida is deemed a bad mother because she did not display the required behaviour of a normative mother: always child-centred, selfless, accountable, and happy. Significantly, the judge tells Frida that they aim to "fix her" (75) and explains that after a year at the facility, "Frida must demonstrate her capacity for genuine maternal feeling and attachment, hone her maternal instincts; show she can be trusted.... [They then] will decide if she's made sufficient progress. If she hasn't, then her parental rights will be terminated" (75). In other words, Frida must prove herself worthy and accountable to the standards of normative motherhood to regain custody of her daughter.

In an interview, Chan explains that the "curriculum of the school is intended to satirize heteronormative (and upper-middle-class) white ideals of motherhood and parenting, which our culture treats as universal" (qtd. in Peterson) and which deem all the women at the school as de facto bad mothers because they fail to achieve the idealized and universalized standards of normative motherhood. Unsurprisingly, most of the mothers at the school are poor and/or racialized. Only a handful of the mothers are white; Frida is the only Asian American mother. This representation, as Chan explains, "gestures to the fact that the way we are watched is different depending on race and class; that we don't all face the same monitoring from the government or the police" (qtd. in Cook). Some of the mothers have been charged with physical abuse of their children, but most are at the school for behaviour that has been interpreted as neglect or abandonment by the dictates of normative mothering. One mother let her eight-year-old daughter walk home from the library alone; another mother let her son wait in a parked car during a job interview, another spent too much time complaining about her child on social media. Under the mandates of what is deemed as normative mothering, as Jennifer Bort Yacovissi emphasizes: "An unsupervised child, is apparently, an endangered child."

Upon arrival at the school, Frida reflects that "She is a bad mother among other bad mothers. She had no history or no other identity" (79). The instructor tells the mothers that "Bad parents must be transformed from the inside out. [They must learn] the right instincts, the ability to make split-second, safe, nurturing, loving decisions" (83). The mothers must continually repeat the school's refrain: "I'm a bad mother, but I am

learning to be good" (83). At the school, the mothers are under constant surveillance, which as Chan explains "makes literal the feeling that a lot of parents have of being watched and judged" (qtd. in LaFleur). The mothers are also assigned dolls who resemble their children. The dolls are "sentient beings who can move, hear, think and speak and feel like children" (102) and who will collect data to "gauge the mothers' love ... and the quality and authenticity of the [mother's] emotions" (103). With the use of surveillance and artificial intelligence (AI) dolls, Chan, as she explains in an interview, "was pondering what if you actually could measure a mother's love? What if you could measure how much attention a mother pays to her child? What if there was a one-size-fits-all standard by which to judge parenting?" (qtd. in LaFleur). Moreover, with the AI dolls, as Chan elaborates in another interview, she "took things [she] was noticing and made them literal—in real life, you're supposed to keep an eye on your child, so in the school you have to lock eyes with your doll at all times or you're punished. It's taking a kernel of truth and making it insane" (qtd. in Miller). The mothers interact with their doll children through nine units of study ranging from "Fundamentals of Care and Nurture," "Dangers Inside and Outside the Home," to "The Moral Universe" (103) to learn how to meet the school's standards of good mothering.

When Chan is asked in an interview about the concept of the AI dolls in her novel, she explains: "I was responding to the Aviv article mentioned above and the way the government officials spoke to that mother in such a clinical way. The way they talked about parenting reminded me a bit of science fiction" (qtd. in Stigler). With the AI dolls, Chan continues, it is "the idea that things like devotion and affection might be 'measured' by some universal standard or metric is made literal" (qtd. in Stigler). Indeed, with each interaction with the AI children, the mothers are measured by a metric of normative motherhood. When one mother questions why the mothers cannot ask their children what is wrong when they are crying, the instructor explains: "A mother shouldn't have to ask questions. She should know" (114). When the dolls cry louder and longer than real children, and the mothers cannot comfort them, the teacher instructs the mothers to manage their frustration: "By staying calm, they're showing their child that a mother can handle anything. A mother is always patient. A mother is always kind. A mother is always giving. A mother never falls apart" (115-16). When

Frida's doll's data is analyzed, it shows that "Frida's hugs are lacking warmth ... and her kisses are lacking a core of maternal love" and that Frida "needs to make more meaningful eye contact with her daughter, have a higher word count [in communication with her daughter] and that her touch should be more loving" (122). Frida is warned that the "data suggests substantial amounts of anger and ingratitude and that any negative feelings will impede her progress" (122). When Frida explains that she is doing her best and that she did not know she would be working with a robot and it is a lot to absorb, the instructor tells her, "not to overthink it" and that she must "practice with the doll to take back those skills to your regular life" (122). In other words, the women's mothering of their doll children is measured by the standardized metrics of the school's curriculum, and only those mothers who learn and perform the conduct of what is deemed normal for mothers will have their children returned to them.

Kathryn Ma rightly observes that "Chan depicts modern standards of motherhood as absurd and flags how these standards are inequitably applied depending on gender, race, culture, and wealth." Moreover, as Chan emphasizes, "The program's parameters for what makes a 'good' or 'bad' mother are intentionally set up to be impossible. There's potential for failure at every turn. If any mothers do succeed, it's somewhat arbitrary, to reflect the unfairness of the system" (qtd. in Stigler). The mothers' behaviours are graded on a curve with both quantitative and qualitative measures, and their scores determine their treatment at the school—whether they are sent to the "talking circle" for further assessment and reprimand and whether the mothers can keep their weekly phone privileges to speak to their children. All the mothers end up in the talking circle and lose their phone privileges; most do not speak to their children for months. The individual mother's final score determines whether she will be reunited with her child. The many tests are set up for failure, and the mothers are blamed for inevitable missteps and accidents. When one mother's doll freezes to death during outdoor play on a cold winter day, the mother is reprimanded as a bad mother "because a mother must never look away" (147). When another doll throws himself against the electrified fence, the mother is blamed for his suicide, charged for the damaged equipment, and assigned a new doll, but because of this incident, reunification with her child is doubtful (171). The dolls are programmed to become sick, and none of the

mothers can fully comfort and cure their doll children. The instructor insists that "The mothers should know the correct sequence of embraces, kisses, and kind words to nurse their doll back to health. The love that awakens the spirit and heals an aching body" (175). One mother while working on seizure protocols was accused of being too aggressive and subsequently failed the unit on child safety (178). In contrast, Frida is told that her moments of hesitation "will impede the child's sense of security" and that "her mother-ease during the feeding test, though joyful, was insufficiently empowering" (180). One mother is reprimanded for being too aggressive while Frida is judged for being too hesitant, showing how the school metrics of normative motherhood set up all mothers for failure.

The third of the nine units of the study "On Reconditioning the Narcissist," "seeks to strengthen a child-first orientation and ability to parent in the face of distraction" (182), and all the mothers in Frida's group fail (189). For example, one mother fails the unit because her doll child hit Frida's doll child and is told that "All accidents can be prevented with close supervision" (199). Frida is also reprimanded and fails that test for speaking too harshly to the doll that hit her doll child because "nothing justifies yelling at a child"; she acted "impulsively" ... and "did not give the other mother space to mother" (202). During a safety unit designed like a race-obstacle course, Frida falls and loses her phone privileges for a month because she is branded as a bad mother for falling, for swearing, and for finishing third. During a unit on focussed play, Frida is accused of shaming her daughter into good behaviour to complete the fifteen-minute test and is told: "Maybe that worked in the cultures you grew up in, but this is America. An American mother should inspire a feeling of hope, not regret" (212). Because the mothers are judged by the universalized ideals of normative motherhood, and because what is being asked of them is simply unattainable, failure becomes inevitable.

Midway through the year of learning to be a good mother, there is an evaluation day where the mothers are required to watch the filmed footage of their interactions with their doll children with sensors attached to their faces and hearts. The evaluations, as Chan emphasizes, "show how the expectations we have of mothers, and how we judge them, are absurd, besides being unjust" (qtd. in LaFleur). Mothers are taught to self-monitor. They must monitor and manage their physical,

psychological, and physiological reactions to match the expectations of the school. Frida's data reveals the following: "Her maternal feeling and attachment is limited. Her word count remains one of the best in class, but analysis of her expression, pulse, temperature, eye contact, blinking patterns and touch indicate residual fear and anger. Guilt. Confusion. Anxiety. Ambivalence" (215). The counsellor concludes that "Frida possesses the intelligence to parent but maybe not the temperament" (215). The night before the evaluation day, one mother commits suicide. The results of evaluation day reveal that the prognosis for return is fair to poor or just poor for almost all the mothers. Learning this, "The mothers imagine what they would do if they had access to knives or scissors or chemicals. Not everyone came to the school a violent woman, but now heading into month seven they all might stab someone" (215). Their time at the school has driven the mothers to develop their wild and outlaw impulses. They are becoming wild because of the loss of their children, and they are outlawed from mothering their children. While these are not necessarily empowered positions, they still enact resistance to normative motherhood to signify feminist maternal power.

A few months later the mothers are further tested when they are allowed to meet the men from the School for Bad Fathers for the unit on socialization. Meeting the fathers, the bad mothers learn that the bad fathers are not as heavily watched, judged, or punished at their school; that there are no talking circles; there have been no suicides or expulsions, and no father has ever lost his phone privilege because "the counselors think it's important for them to stay in their children's lives" (224-25). The fathers' school, as Tucker, a father Frida meets, explains, "has been, for the most part, a supportive group" (225). With the fathers in the novel, Chan explains she wanted to "show the double standard women face when it comes to raising children" (qtd. in Rooney) and how "our society treats fathers differently" (qtd. in Stigler). In the novel, Rooney emphasizes, that "while parents of all genders suffer in this fear-based culture, the brunt of the struggle still tends to be borne by the mother." Indeed, while Tucker only has to say that he is "a father learning to be a better man", Frida must say: "I'm a narcissist. I am a danger to my child" (226-27).

As the fathers in the novel show how the judgment and surveillance of parents are gendered, they also reveal how motherhood is defined and enacted through and in the denial of maternal sexuality. Though not

explicitly part of the school's curriculum, the men are brought in near the end of the training as a final test and judgment of good motherhood. Under these standards, mothers are assumed and required to be non-sexual. However, and unsurprisingly, many of the heterosexual women who have been without romantic or sexual companionship for close to a year become involved with the fathers. But, as the novel emphasizes, "Besides suicide and self-harm, forming romantic attachments during training is the height of selfishness. Pursuing a romantic attachment suggests a desire to fail" (280). The selfishness of self-harm, suicide, and maternal sexuality, signify, like the mothers' violent impulses discussed earlier, wild and outlaw maternal subjectivity. Some mothers suggest that the school "wants more fraternizing and expulsions so they can test out the registry"; others say "the school wants to keep them distracted so more mothers will fail" (272).

Frida begins a relationship with Tucker and "is the happiest she has been since losing Harriet" (246), and since meeting Tucker, "she hasn't thought about the bell tower [where one of the mothers committed suicide] even once. She no longer dreams of murdering her counselor and has regained her appetite" (239). Here we see Frida becoming a mother outlaw, wild with child. The instructors threaten to send Frida back to the talking circle because of reports of flirtations with Tucker. Later Frida is sent back to the talking circle for "sexually suggestive touching ... and ignoring her doll," (280) indicating indeed that under normative motherhood as enacted in the school's assessment and judgement, a sexual mother is a negligent mother. When Tucker gives Frida his phone number so that they may meet when they leave their schools, Frida reflects that "She is a bad mother for hanging on those words. She is a bad mother for missing him. She is a bad mother for desiring him" (281). Later, Frida learns that the prognosis for having Harriet returned is fair to poor and is told that "while she scored high for tenderness, empathy, and care ... there were certain spikes of desire when she watched footage of herself with Tucker; and that he distracted her from her training" (290). While Frida protests this assessment, emphasizing that she has "completed the hardest assignment; that she taught her doll to be human" (290), the instructor informs her that while "the judge will consider all the data, [her] scan was supposed to come back clean and maternal" (290). For the school and under the dictates of who they consider normal mothers even a suggestion of maternal sexuality nulli-

fies the most caring and tender mothering. Although Frida atones for "her shortcomings one last time," accepting that she is a bad mother because [she] desired (291), the judge at the hearing, after a review of Frida's file, terminates her parental rights. Significantly, the judge explains: "What made the program so special was having the child's perspective ... and with the data and with the technology, the court had a full picture of Frida's abilities; her character. And from this were able to able to extrapolate" (299). The judge's reasoning and verdict confirm the child-centredness of normative motherhood and its surveillance, which caused Frida to be observed and judged as a bad mother. As Frida listens to the judge's decision, she reflects: "She looks conservative and tidy, not the mother she was before, not the mother she became, but a mother form, a manual, blank and interchangeable" (298). Despite the novel's satirical critique, Frida's reflections here suggest that she has been indoctrinated into normative motherhood and internalized the school's teaching to see herself as a bad mother, and the only means to rectify this is complete submission to and acceptance of the school's teachings. However, the novel invites another reading in which Frida enacts the satire to refuse, resist, and ultimately escape from the institution of normative motherhood to rename herself as a good mother outside the dictates of normative motherhood. To this discussion, I now turn.

Maternal Resistance: "A Different Ending with the Mother Making the Rules"

In her interview, Diane Cook asks Chan to discuss how the mothers balance their sense of self and roles as moms. Chan replies that she "wanted to explore how Frida holds onto her integrity while being indoctrinated ... [and to explore] how despite the school saying 'all you are, is a mother. You should have no other thoughts or desires besides your child' ... the mothers desperately cling to what remains of their identity and keep some part of themselves secret and out of reach" (qtd. in Cook). I suggest that although Frida seems to have internalized the teachings and, in some ways, accepted them as true, she continued, despite the repercussions, to act in ways that express her maternal authenticity. And in the final realization of her agency, when Frida kidnaps her daughter, she renames herself as a good mother. In this way, *The School for Good*

Mothers may be read as a spiritual quest wherein, as theorized by feminist theologian Carol Christ, Frida has experiences of nothingness, moves to an awakening, and then achieves insight that delivers a new naming of self and world. Reading this as a novel with a mother as the hero of a spiritual quest, the nothingness that opens Frida's journey is the loss of custody of her daughter due to the judgement of others and being watched so carefully. The awakening is Frida's understanding of how that judgement of normative mothering functions to oppress a woman leads to her reclamation of maternal authenticity and the realization of her maternal power. Finally, this insight delivers new and empowered meanings of the good mother that by the novel's end allows Frida to, literally and metaphorically, escape from the institution of others judging her motherhood.

Frida's despair and grief at the loss of her daughter signifies the nothingness that opens the spiritual quest. However, even at this stage, Frida seeks to refuse and resist the police, social workers, psychologists, and the judge scripting and positioning her as a bad mother. Frida, as noted above, explains that her daughter was not abused or neglected, just that she "had one very bad day" (13) and that her mothering should not be judged or reduced to this one mistake (6). Frida emphasizes that "What happened last week, what I did, doesn't represent what kind of mother I am" (44). Indeed, what Frida is insisting here, as noted by Arianna Rebolini, is that "a person is more than their worst mistake." Significantly, Frida also understands that it was the larger societal conditions of judgemental motherhood—a single mother separated from her husband with an ill and fussy infant, engaged in paid work while also being responsible for the care of a child, doing so without friends or community/family support, and with financial constraints—that lead Frida to make this one mistake. Frida reflects that "On her bad day, she needed to get out of the house, out of her mind, trapped in the house of her body, trapped in the house with Harriet" (13) However, Frida also remembers, although she would admit it to no one, that "She felt a sudden pleasure when she shut the door, and got in the car, that took her away from her mind and body and house and child; the pleasure of the drive propelled her: it wasn't the pleasure of sex or love or sunsets, but the pleasure of forgetting her body, her life" (14). Though not yet fully understood by Frida at the first stage of her quest, it is precisely that oppressiveness of normative motherhood that caused Frida, perhaps

recalling Nora in Ibsen's *The Doll's House*, to shut the door and leave. As Frida later reflects: "She never claimed her space. Maybe some people weren't meant to claim their space. She claimed it for two and half hours and lost her baby" (38). Indeed, what Frida is guilty of, and what will be the focus of her rehabilitation at the school is not, as Molly Young explains, "a sin of parenting but of ontology. She has violated a new code of maternal ethics by conceiving herself as a daughter, lover, employee, and citizen rather than a mother alone. The corrective action she must take, then, is to slaughter all superfluous selves." In leaving the home that day, albeit at a risk to her child, Frida is claiming those superfluous selves; selves that Frida seeks to safeguard at the school despite her indoctrination into normative motherhood, and ones she releases with her final escape and renaming of the meaning of good mother.

LaFleur argues that surveillance and performance are at the heart of the novel, while Nylah Burton argues that its focus is an exploration of penance and resistance. I suggest that the novel takes up all four concepts in scripting the novel as a quest that propels Frida from guilt to understanding, to an awakening, and finally, to resistance. At the start of her quest, while Frida may refute how she has been labelled a bad mother for her one mistake, she does feel guilt and remorse and knows that she put her daughter at risk by leaving her alone at home. Frida explains to her psychologist: "I know what I did is completely unacceptable. I couldn't be more ashamed. I put my daughter in danger" (44). She apologizes again to her daughter, "knowing that she might be beginning years of apologizing, that she's dug herself a hole from which she may never emerge" (9). Frida's apologies and explanation signify atonement, or, in Burton's words, penance. While there is penance at the start of Frida's quest, Frida, as also observed by Burton, moves to resistance. However, I suggest this resistance is part of the larger interplay between surveillance and performance, as noted by LeFleur. I suggest that Frida comes to claim her authenticity and power even as she performs normative motherhood to regain custody of her daughter under the school's surveillance. In other words, Frida does not entirely internalize the dictates of motherhood but learns to perform them as necessitated by the school's surveillance. In her interview with Chang, Cook comments: "I loved how the so-called bad moms who are being punished for their bad mothering push back. They think 'there must be something good about me right?' The only way they can get their kids

back is to conform to these state-sanctioned standards which are totally out of reach and yet, they defiantly hold on to pieces of themselves though the stakes are so high." Frida comes to realize "that there is something good about me" (Cook), as she begins to claim her authenticity and agency to question and resist the teachings of normative motherhood even as she must perform it under surveillance. Indeed, she realizes that "This whole year may depend on playing along" (83).

Despite their surveilled performances of normative motherhood, the mothers do question and protest the absurdity of the tests and evaluations. When one mother quits, and the others are told that this mother will be added to the bad mothers registry "the mothers whisper 'fuck this'" (113). When another mother asks why she cannot simply ask her doll child why she is crying, Frida reflects: "There is no good reason why the dolls can only play with one toy at a time" (211). In their questioning, the mothers are challenging the school's scripting of what constitutes proper maternal behaviour. There are also thoughts, words, and acts of resistance. One day, Frida tells her doll: "Mommy doesn't want to play, not now. Now is naptime. Close your eyes please" (156). When the doll talks back, Frida reaches down into the crib and pinches her doll's arm (156). During the unit on focussed play, Frida concedes to boredom and reflects: "The hardest part is staying cheerful and amazing" (211). Another time, Frida admits that "her anger consumed her" (159). When the instructor suggests that Frida's mother should have sought help for her depression, seen a therapist, or found a support group, Frida thinks but resists saying that those were American solutions (283). At the dance, Frida reflects: "In a just world the mothers would have tomato sauce to throw on Ms. Knight [the instructor]. A bucket of pig's blood" (260). These thoughts and actions—admitting to anger, not agreeing with the instructor's advice, and imagining retaliation—position the mothers as mother outlaws, wild with child, to enact feminist maternal power. While she reflects on her surveillance footage, Frida also perceptively realizes: "The woman in the video has nothing to do with how she parents Harriet. How can the school expect her to love [a doll] like her own? To behave naturally, when there's nothing natural about these circumstances?" (214). Some mothers engage in a hunger strike, others attack the guards, and others quit or escape. One mother commits suicide. Some mothers have sex with the male guards. Others have relationships with each other or with the bad fathers, and many form

"sisterhoods based on shared incompetence" (208). Each thought, word, and act of protest signifies Frida's and the other mothers' awakenings, the safeguarding of their authenticity, and the enactment of their agency, as the mothers, in Cook's words noted above, "defiantly hold on to pieces of themselves though the stakes are so high."

Significantly, for Frida, it is in and through maternal sexuality that her authenticity is affirmed, and her agency realized. This affirmation and realization are symbolized in Frida's recurring visions of a house with a sideways light. As noted above, Frida left Harriet alone because "she needed to get out of the house of her mind, trapped in the house of her body, trapped in the house with Harriet" (13). Near the end of the novel, Frida realizes that she "wants another house ... one where the light comes in sideways. The light will blaze through the windows. Every room flooded with brightness" (257). Frida wants to tell Tucker about "the house of her mind, the house of her heart, the house of her body" (236). She imagines adding rooms to this imaginary house wherein the mothers will be together with their children, where "the mothers will have a mother house" (266). With Tucker, Frida continues to think about "towns and houses" and "light that comes in sideways" (285). Later, Frida "thinks of Harriet in winter, the house with the sideways light, pulling her door closed, driving away" (291). While the metaphor of the house specifically references Frida's imaginings that she and Tucker will live together when their children are returned to them and that she will be pregnant with their child (257), I suggest that the recurring image of the blazing and sideways light also symbolizes Frida's awakened sense of herself as a mother.

At the end of the novel and her quest, Frida acts upon her awakened authenticity and kidnaps Harriet, and although Frida is aware that she will have only days or hours with her daughter before they are found, she thinks: "No matter what happens, there will be comfort and pleasure. A moment with her daughter where she will make the rules. A different ending" (my emphasis; 315). Frida further reflects: "The instructors would be proud. She moves faster tonight than she ever did at the school. She harnesses her fear for strength and speed" (317). This speed and strength signify her resolve to act upon her authenticity and agency and to claim her daughter as her own. Frida then slips the Polaroid picture of their final visit together in Harriet's jacket so that when they are found, and Harriet is older she will learn "a different story" (319). One

day, as Frida reflects, "She will tell Harriet about her other daughter, Emmanuelle, the doll, and about the mothers at the school", and will tell her "How the making of a new person in her body defies language and logic. How that bond can't be measured. That love can't be measured" (319). She will tell Harriet, in the words that conclude the novel: "*I'm a bad mother. But I have learned to be good*" (319). Importantly, this goodness is not dictated by normative motherhood or as instructed in the school's teachings but by Frida's own awakened and resistant renaming of herself as a good mother.

Conclusion: "The Emotional Gut Punch ... [and] Full Knockout Wallop" of *The School for Good Mothers*

In an interview, Chan remarks: "I don't think it's possible to be a good mother because what American society expects of mothers is to do everything and be everyone with no support" (qtd. in Stigler). The lesson of *The School for Good Mothers* is, indeed, the impossibility of good motherhood. But more specifically and importantly, and as I have argued in this chapter, the novel, in its dystopian satire, where everything is as bad as it can be, and through Frida's quest, reveals that the good mother is not derived from normative motherhood but rather through mothers' realizing their maternal authenticity and agency to define and claim their meanings and practices of mothering. One reviewer contends that "The closeness to reality is what turns the book's emotional gut punch into a full knockout wallop" (Knibbs). But I suggest that the novel may also be read with an alternative emotional gut punch and that is the possibility of feminist maternal power through the undoing of this judgement of motherhood. Although Frida's story is not necessarily empowering in the traditional sense, nor does it have a particularly happy ending, Frida does hold onto her selfhood, and in kidnapping her daughter Frida, does defy and escape from that other motherhood to become a mother outlaw, wild with child. Indeed, it may be the powerful satire of that motherhood, and Frida's empowered resistance to it, that is the full knockout wallop of the novel.

Works Cited

Borrelli, Christopher. "Oak Park's Jessamine Chan invented 'The School for Good Mothers'—A Little Too Disturbingly Close to True." *Chicago Tribune,* 14 Jan. 2022, https://www.chicagotribune.com/entertainment/ct-ent-school-for-good-mothers-chan-20220114-4rklqwnfrfgjllofvmcyrpd6h4-story.html. Accessed 28 Feb. 2024.

Bort Yacovissi, Jennifer. "The School for Good Mothers: A Novel." *Washington Independent Review of Books,* 9 Feb. 2022,https://www.washingtonindependentreviewofbooks.com/index.php/ bookreview/the-school-for-good-mothers-a-novel. Accessed 28 Feb. 2024.

Brooks, Kim. *Small Animals: Parenthood in the Age of Fear.* Flatiron Books, 2018.

Burton, Nylah. "Policing Parents: Jessamine Chan's 'The School for Good Mothers' Imagines a Carceral State for 'Bad' Moms." *Bitch Media,* 20 Jan. 2022, https://www.bitchmedia.org/article/school-for-good-mothers-jessamine-chan-review. Accessed 28 Feb. 2024.

Chan, Jessamine. *The School for Good Mothers.* Simon & Shuster, 2022.

Christ, Carol. *Diving Deep and Surfacing.* Beacon Press, 1995.

Cook, Diane. "Who Decides What Makes a Good Mother." *Electric Literature,* 12 Jan. 2022, https://electricliterature.com/jessamine-chan-novel-the-school-for-good-mothers/. Accessed 28 Feb. 2024.

Hays, Sharon. *The Cultural Contradictions of Motherhood.* Yale University Press, 1996.

Knibbs, Kate. "Dystopia Is All Too Plausible in The School for Good Mothers." *The Wire,* 24 Jan. 2022, https://www.wired.com/story/school-for-good-mothers-dystopian-reality/. Accessed 28 Feb. 2024.

LaFleur, Margaret. "'Writing about motherhood provides a great vantage point from which to write about society': An Interview with Jessamine Chan." *Ploughshares,* 4 Jan. 2022, https://blog.pshares.org/writing-about-motherhood-provides-a-great-vantage-point-from-which-to-write-about-society-an-interview-with-jessamine-chan/. Accessed 28 Feb. 2022.

Ma, Kathryn. "Review: Darkly imagined tale of where bad mothers go to learn better." *Datebook,* 28 Dec. 2021, https://datebook.sfchronicle.com/books/review-darkly-imagined-tale-of-where-bad-mothers-go-to-learn-better. Accessed 28 Feb. 2024.

Miller, Stuart. "How Novelist Jessamine Chan Created the Dystopian 'School for Good Mothers.'" *The Orange County Register,* 8 Jan. 2022, https://www.ocregister.com/2022/01/08/how-novelist-jessamine-chan-created-the-dystopian-school-for-good-mothers/. Accessed 28 Feb. 2024.

Peterson, Sara. "Jessamine Chan Takes Aim At 'Good Mom' Worship in Her New Book." *Refinery 29,* 18 Jan. 2022, https://www.refinery29.com/en-us/2022/01/10833916/school- for-good-mothers-author-interview. Accessed 28 Feb. 2024.

Rebolini, Arianna. "Jessamine Chan's Explosive The School for Good Mothers Probes a Parent's Worst Nightmare." *Oprah Daily,* 5 Jan. 2022, https://www.oprahdaily.com/entertainment/books/a38677378/school-of-good-mothers-jessamine-chan/. Accessed 28 Feb. 2024.

Stigler, Britt. "Jessamine Chan's Debut Novel Asks if it's Possible to be a 'Good' Mother."*AllArts,* 11 Feb. 2022, https://www.allarts.org/2022/02/jessamine-chan-the-school-for-good-mothers-interview/. Accessed 28 Feb. 2024.

Young, Molly. "A Chilling Debut Novel Puts Mothers Under Surveillance and Into Parenting Rehab." *The New York Times,* 28 Jan. 2022, https://www.nytimes.com/2022/01/11/books/review-school-for-good-mothers-jessamine-chan.html. Accessed 28 Feb. 2024.

17.

Mama

Zoë Zeng

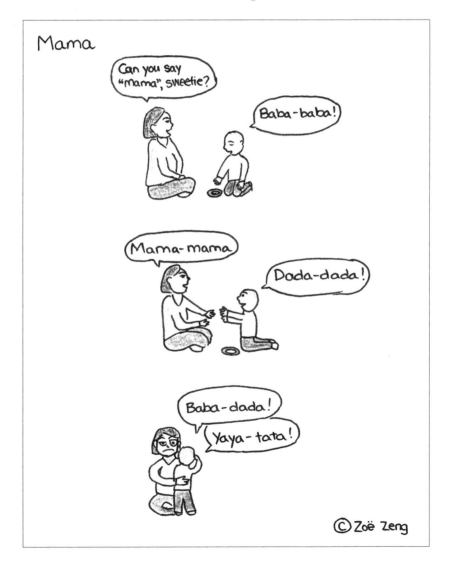

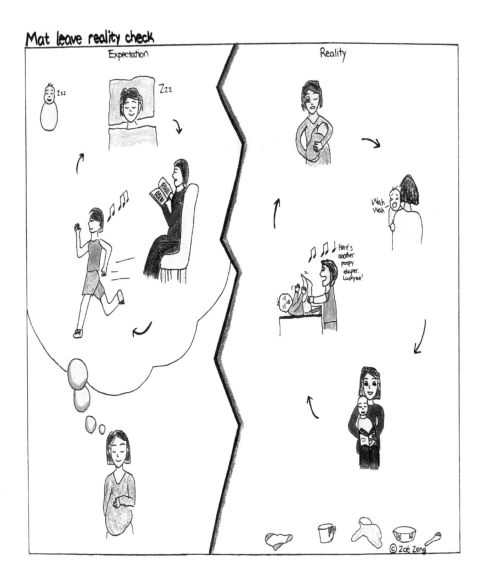

Notes on Contributors

Rebecca Jaremko Bromwich is a solo mom to four, a lawyer, a law professor, and a writer of fiction and nonfiction. She works as a lawyer in private practice and teaches at Sprott School of Business at Carleton University in the MBA program.

Guinevere Clark is a poet, dancer, nurse, and founder of Poetry Into Light. She has a Creative Writing PhD from Swansea University, UK. Her thesis, *The Egg in the Triangle*, explores matricentric feminism and liminality to present poetic intersections of motherhood, sexuality, and place. She has international literary awards with The Wales Poetry Award, Cinnamon Press, Ambit and Hammond House, and poems published in Atlanta Review, Minerva Rising, A3, Magma, Culture Matters and Poetry Wales. Her first collection is *Fresh Fruit and Screams* (Bluechrome, 2006). She teaches poetry and dance in community, is studying Creative Producing, working on a new poetry book, academic editing and is a mother to Sol. All collaborations welcome. www.poetryintolight.org or www.guinevereclark.com

Jennifer Cox (she/her) is a poet, mother, and lawyer. Her poetry primarily revolves around motherhood, birth, and the climate crisis. Her writing has previously appeared in numerous publications, including Arc Poetry Magazine, ROOM Magazine, the League of Canadian Poets' Poetry Pause and Literary Mama. She resides in Ottawa with her family.

Micha Colombo is a UK-based writer-performer working in theatre and poetry. Her poetry has been published in *OrangesJournal.com*,

Heartache and Hope anthology, *Birch Moon Press*, and *Hot Poets Sparks* anthology. Playwriting credits include *I Am Medusa* (Exeter Fringe R&D Programme 2021), *Branded*, (Theatre West Development Programme 2021), *Flight* (long-listed, Bread & Roses 2019 Playwriting Award), and *Mum's the Word* (winner, Chesil Theatre Playwriting Competition 2018). She is an associate artist with Lazarus Theatre, an Exeter Northcott Theatre Futures Programme alumnus, holds an MA from the Academy of Live & Records Arts, and is a mom to three children. www.micha colombo.com

Andrea DeKeseredy Andrea DeKeseredy is a PhD student in the sociology department at the University of Alberta. She holds two master's degrees, one in social work and one in sociology. Her research focuses on gender, work and family. You can follow her on X at @AndieYEG.

Elana Finestone is a lawyer, mentor and mom to one wild toddler. Her purpose in life is to create safer spaces for people to be their authentic selves.

Linda Greene-Finestone is a public health epidemiologist and nutritionist who fell in love with painting fifteen years ago. Her medium is acrylic, which she finds immediate and versatile. Her subject matter includes landscape, people and abstract works, and often the former are portrayed abstractly. The painting *Lilith and the Pomegranate* might be called a version of magic realism. Linda is drawn to fluid forms that are often spherical. There is something telling about what is kept within and what is outside. A peering into the intimate within the shell, and the crisp or often blurred encounter with the external space. Linda's works are found in collections in Vancouver, Toronto, Ottawa, Montreal, Boston, and Tel Aviv.

Sheri Furneaux is a Boston-based photographer dedicated to giving space for other members of their LGBTQIA+ community to stand in their power. Inspired by Cindy Sherman, Nan Goldin, and Tommy Kha, their work focuses on the soft spot in between poses by striving to create candidness and vulnerability within a crafted set. All images are provided with permission.

May Isaac is an Australian writer and feminist. www.womenandwork. com.au

Clara Kundin is a theatremaker, educator, mother, and art model. She is currently pursuing her MFA in theatre for youth and community at Arizona State University. Her research focuses on accessibility and the intersection of parenthood and theatre. www.clarakundin.com

Hazel Katherine Larkin studied theatre before leaving Ireland for the UK. At twenty, she moved to Asia, where she spent twelve years. Within a year of returning, Hazel was Ireland's first practising doula and had started university. She now holds an honours BA in psychology and sociology, an MA in sexuality studies, and an LLM in international human rights. Her doctoral research focused on transgenerational trauma, Irish women, and child sexual abuse. Hazel works with individuals and groups dealing with the trauma of abuse and provides doula services exclusively to women with histories of child sexual abuse. www.traumarecovery.ie

Wendy McGrath is the winner of the inaugural Prairie Grindstone Prize and is a Métis poet, writer, and artist living in amiskwacîwâskahikan (Edmonton). Her most recent book is the poetry collection, *The Beauty of Vultures* (NeWest Press forthcoming Spring 2025), inspired by and including the bird photography of musician Danny Miles. McGrath's writing embraces multiple genres—fiction, poetry, spoken word, and creative non-fiction. She has collaborated with visual artists and musicians to explore the relationships between genres. McGrath has published six books—four novels and two books of poetry—and two chapbooks which explore a range of forms and approaches. Much of her work can be described as prairie gothic. She has a Master's Degree in English from York University.

Lauren McLaughlin is an artist, curator, writer, and activist based in Edinburgh, Scotland. Her work encompasses a range of materials and processes from collage, neon, and installation to socially engaged and curatorial projects. Throughout her practice, Lauren seeks to amplify the invisible, overlooked, and undervalued experiences of mothering, carework, and economic inequality. Her work has been exhibited throughout the UK and Europe and is held in permanent public collections. Lauren is also the founding director of Spilt Milk Gallery CIC; a not-for-profit based in Edinburgh whose mission is to support

the work of artists who identify as m/others. www.laurenmclaughlin. co.uk www.spiltmilkgallery.com

Andrea O'Reilly, PhD, is a full professor in the School of Gender, Sexuality and Women's Studies at York University and has twice received the university's Professor of the Year Award for teaching excellence. She also was the 2019 recipient of the Status of Women and Equity Award and is the founder and editor-in-chief of *The Journal of the Motherhood Initiative* and publisher of Demeter Press. Aside from her teaching, Andrea has published three monographs and edited or co-edited 30 plus books, and she is the editor of the *Encyclopedia of Motherhood* (2010) and co-editor of the *Routledge Companion to Motherhood* (2019). She has received more than $1.5 million in grant funding for her research.

Sarah Sahagian is a feminist writer, podcaster, and proud non-profit executive. Her byline has appeared in such publications as *Refinery29*, *The Washington Post*, *The National Post*, and *Elle Canada*. She is passionate about books, mental health, and maternal well-being. Sarah lives in Toronto with her husband and daughter.

Laura Simon is a forty-one-year-old mother of two children and has been in a relationship for more than seventeen years. She had been working as a teacher of politics and French at a German high school. Last year, she finally fulfilled her dream by doing what she has always wanted to do and what she loves: Arts. Laura is currently studying at the University of the Fine Arts in Berlin. In collaboration with the university, she is currently working on a performance video as well as a sound installation on the theme of regretting motherhood. Laura's work can be found on Instagram: laurasimonart.

Zoë Zeng currently lives in Ottawa with her partner and their two year-old son. Alongside her work as a lawyer for the federal government, motherhood has been an interesting ride for Zoë as she grew up with her grandfather until she was 11 years-old. She therefore couldn't benefit from the intergenerational knowledge-sharing that typically happens between mother and daughter, especially relating to the first decade of a child's life. That said, Zoë is grateful for all the love and support from her stepmother and father as well as that from her in-laws. Together,

Zoë and her partner will continue to navigate the challenges and excitements of parenthood.

Claudia Zucca is of Italian and English extraction, born in South Africa. She completed her PhD in comparative literature in 2020. She is currently an Adjunct English Professor, English Professor in International Relations and Primary Education at the university of Cagliari, Italy, and in collaboration with her university colleagues at Sussex University, Claudia cofounded the group *Spread the Word Poetry*. She has participated in various international conferences and workshops and published scholarly articles. Claudia is a member of the American Comparative Literary Association (ACLA) and is an International Advisory Board (IAB) member at Horizon JHSSR for the term 2022–2025. More details about Claudia can be found at https://www.linkedin.com/in/claudia-zucca-602b0339

Deepest appreciation to
Demeter's monthly Donors

DEMETER

Daughters
Tatjana Takseva
Debbie Byrd
Fiona Green
Tanya Cassidy
Myrel Chernick

Sisters
Amber Kinser
Nicole Willey

Grandmother
Tina Powell